CAPE COD
Jazz

FROM COLOMBO
to THE COLUMNS

JOHN A. BASILE

Foreword by Dick Golden

THE
History
PRESS

Published by The History Press
Charleston, SC
www.historypress.net

First published 2017

Manufactured in the United States

ISBN 9781467119320

Library of Congress Control Number: 2017931811

Notice: The information in this book is true and complete to the best of our knowledge. It is offered without guarantee on the part of the author or The History Press. The author and The History Press disclaim all liability in connection with the use of this book.

Contents

Foreword, by Dick Golden 5
Acknowledgements 9
Introduction 11

PART I: THE MUSICIANS
Marie Marcus 15
Lou Colombo 19
Dave McKenna 24
Bobby Hackett 27
Dick Wetmore 30
Ruby Braff 38
Bob Wilber 41
Bart Weisman 44
Musicians and Memories 47

PART II: THE PLACES
Bournehurst-on-the-Canal 75
The Columns 80
The Atlantic House 83
Storyville Cape Cod 87
The Places They Played 93

CONTENTS

PART III: BEYOND CATEGORY
Jack Bradley 101
Dick Golden 105
Karyn Hewitt 109
Cape Cod Jazz Festival 111
Cape Cod Jazz Society 114
On the Record 117

Bibliography 123
Index 125
About the Author 127

Foreword

Cold Cape Cod clams 'gainst their wish do it…
Even lazy jellyfish do it…
Let's do it, let's fall in love.
—*Cole Porter, "Let's Do It," 1928*

The jazz legacy on Cape Cod is a rich and inspiring story. While we mostly associate the creation of this uniquely American art form, jazz, to the cities of New Orleans, Chicago, St. Louis and New York, Cape Cod—the area that informed playwright Eugene O'Neill's writing and Edward Hopper's painting—has been a performance magnet for our jazz masters and home and inspiration to several musicians with world-renowned reputations.

John Basile's book is a well-researched and excellently written history of the intersection of the music and "the place." Not only is John a highly regarded journalist and longtime Cape Cod resident, but also he has had a lifelong interest and appreciation of the music (he plays trumpet if you ask him to) and is really an important part of Cape Cod jazz history for his leadership in the 1990s of the Cape Cod Jazz Society.

I consider myself so very fortunate to have been able to host a commercial radio music program of jazz and American standards on a highly listened to station and to have had such a rare honor to enjoy complete "freedom of expression."

I joined WQRC in Hyannis in June 1972 as morning host and within a year had the added responsibility of producing a weekly public affairs program

titled *Panorama*. This project gave me the opportunity to create an hour-long program that featured segments spotlighting cultural and civic activities on the Cape and develop features that reported on events of regional and national significance. In May 1974, Edward Kennedy "Duke" Ellington died, and a friend of mine who worked at WCBS, all-news radio, in New York City called to say his station was going to carry live the Memorial Day funeral service held at St. John the Divine Church in Manhattan—the same church that presented the premiere of Duke's Second Sacred Concert in 1968. I was excited about the prospects of having a reel-to-reel recording of such an inspired tribute—Joe Williams and Ella Fitzgerald singing, Earl Hines and Mary Lou Williams among the musicians performing in Ellington's memory (Count Basie was among the congregants), Brock Peters reciting poetry and a memorial eulogy by Ellington's friend and biographer Stanley Dance:

> *It is hard to do justice to a beloved friend especially when the friend was a genius of the rarest kind. So first the basic facts of his temporal existence.*
>
> *Edward Kennedy Ellington, Duke Ellington, born in Washington, D.C., in April 1899, died in New York in May of 1974.*
>
> *Now some may claim him as a citizen of one or either of those two cities, but he was not. In the truest sense of the phrase, he was a citizen of the world. That is a cliché, perhaps, but few are those who deserve it as he did. He was loved throughout the world, at all levels of society, by the French and Germans, by English and Irish, by Arabs and Jews, by Indians and Pakistanis, by atheists and devout Catholics and by communists and fascists alike.*
>
> *So, no, not even this city in which he said he paid his rent and had his mailbox, not even this New York can claim him exclusively as their own.*

When I listened to those words and the music on the tapes, I knew WQRC had to commit itself to sharing portions of the funeral ceremony to be interspersed by recollections of the Duke Ellington legacy from some of the famous jazz artists who lived in the area at that time. (Marie Marcus, Dave McKenna and Bobby Hackett were among those who shared Ellington memories.) Don Moore, who owned the station, gave his approval for the broadcast, and I believe it was a seminal moment in my radio life because I think Don perceived my passion for the music and the performers. Two years later, in June 1976, when Chatham's Bobby Hackett died, I was able to create another appropriate radio tribute for our audience. (There were about ten stations in the area at that time, and WQRC was the only one to acknowledge

the passing of Robert Leo Hackett.) Then, in September 1977, Don Moore invited me to create and host an evening jazz program that began as *PM Cape Cod*. (In 1985, the program became *Nightlights*, to allow its broadcast on our Vero Beach, Florida station, WGYL.) It was subsequently transferred to OCEAN 104, when, in the spring of 1998, Greg Bone purchased that Cape station (from Don Moore!), and the nightly radio program of jazz and standard continued to air on Cape Cod until December 2005.

I have such wonderful memories of not only having such programming freedom but also that the program found such a large audience, composed of some of the most interesting, dedicated, knowledgeable, inspiring and responsive listeners a radio host could aspire to entertain.

One part of the history of the program, one I still find so rewarding and one that almost feels like there was a destiny to that chapter in my radio life, is that the 1977 start of *PM Cape Cod* parallels the first few years of the creation of what would become a leading record label for mainstream jazz: Concord Records in Concord, California. Attorney Jim Julian, who lived with his family in Dennis, was an early supporter of the QRC radio program, and he put me in touch with his brother Al, who was one of the most respected record-promotion people in the New England area. Al had recently joined Concord as its New England promotions director, and once he heard about the artists I was playing on the air, he immediately sent me a copy of one of Concord's newest releases, *A Good Wind Who Is Blowing Us No Ill*, featuring one of Providence, Rhode Island's young rising stars, saxophonist Scott Hamilton. Within a couple of years, Cape Cod's internationally beloved piano genius Dave McKenna was signed by the label and recorded his first solo Concord sessions, *Giant Strides*, in May 1979. Now an audience comprising Dave's hometown and southeastern New England family, friends and fans could hear those Concord McKenna recordings on the radio. And because the Cape Cod area attracted visitors from all over the world, when residents tuned in to the radio program, they were exposed, in many instances, to some exceptional jazz talent who called the Cape home.

Soon, artists with Cape Cod and southern New England roots—people like Ruby Braff, Carol Sloane, Nat Pierce, Jake Hanna, Lou Colombo, Dick Johnson, Gray Sargent and Marshall Wood—would have the opportunity to record with Concord Records, a company that offered artistic freedom and beautifully engineered and packaged LPs and CDs. In the 1970s and 1980s, the label, now the recording home to our Cape Cod giants, would sign such recognized giants as Mel Torme, George Shearing, Ray Brown, Rosemary Clooney, Carmen McRae, Monty Alexander, Herb Ellis, Barney

Kessell, Hank Jones, Woody Herman, Ernestine Anderson, Harold Jones, Gene Harris, Howard Alden, Charlie Byrd, Ken Peplowski, Buddy Tate, Susannah McCorkle and Al Cohn. This was confirmation for so many of us that the jazz artists who called Cape Cod home belonged in that special galaxy of jazz giants on Concord Records. And now, with a Cape Cod radio program airing this music each evening, their marvelous and timeless recorded performances would reach open and receptive ears, hearts and minds of a very engaged radio audience. They would not be artistic "prophets without honor" in their hometown.

A permanent record of what I feel is the penultimate moment in this local artists/Concord Records chapter was recorded on Sunday afternoon, May 3, 1992, at the Cape Codder Hotel on Route 132 in Hyannis. Concert producer Milt Stevens asked WQRC to cohost "The Concord All-Stars on Cape Cod." The station would promote the event, and I would coproduce (with Milt) and emcee the concert. Carl Jefferson, founder and owner of Concord Records, made plans to fly to the Cape and, with a superb engineering team (led by Randy Ezratty, whose credits include being the engineer for Bob Dylan's MTV *Unplugged* album, Barbra Streisand's 1994 album *The Concert* and David Bowie's *VH1 Storytellers* project), record the performance, which was released as *The Concord All-Stars on Cape Cod* (Concord CCD-4530). The beautiful watercolor of the Chatham view of Pleasant Bay that graces the CD cover was painted by gifted Cape Cod artist Richard Kirk. It is one of the many, many highlights of my radio days on Cape Cod. Some of the world's most talented jazz musicians—artists with a deep personal connection to the Cape Cod area, including Dave McKenna, Scott Hamilton, Chuck Riggs, Gray Sargent, Marshall Wood and Carol Sloane—were captured performing before a very enthusiastic Cape Cod audience. Milt and I came up with a Cape Cod Music Award, which I presented to Jefferson on stage after intermission—a moment we created to thank him for recognizing the jazz talent Cape Cod has inspired and nurtured through the years. Recently, Marshall Wood told me he recalled that after the concert Carl Jefferson invited Gray Sargent to record for Concord Records.

That represents just one story of the history of the music we all love and how it has persevered and flourished through the years on Cape Cod. John Basile's writing, his insights into people and his knowledge and passion for "America's music" informs every chapter you're about to read. It's a personal and professional honor to have been included!

—DICK GOLDEN, September 2016

Acknowledgements

I am by nature a saver. I hold on to photographs, newspapers and magazine clippings and other bits of information I think I can use someday. Well, that someday is here. For years, I put aside information on the many wonderful jazz musicians I have met during my three-plus decades on Cape Cod, and now much of that information is compiled in book form.

But this is more than just a collection of odd bits of information. I hope it tells a story of how a distinctive place embraced a distinctive music and the people who make it.

I want to thank everyone who shared his or her story with me. Some of you had to sit through more than one interview while I got my facts straight. Your patience is as impressive as your music. To those who met me in coffee shops or backstage after gigs, invited me into living rooms or endured repeated e-mails, I offer a heartfelt "thank-you."

This is your story.

Introduction

Who first played jazz on Cape Cod? Who was the first to pick up a trumpet, a clarinet or a trombone and play a hot lick never before heard on the sandy peninsula?

That question will have to remain unanswered, but what is known is that jazz—the most American form of music—has a solid place in Cape Cod culture.

History tells us that the music we now call jazz emerged from multicultural New Orleans in the early twentieth century and quickly spread to cities such as Chicago, St. Louis and other points north and west of New Orleans.

Seaside Cape Cod, jutting into the Atlantic Ocean along the eastern coast of Massachusetts, seems an unlikely place for jazz to thrive. But the music, born in the American South and popularized in big cities, found a home on Cape Cod within a few years of its creation.

While Cape Cod did not have the urban sophistication of New York, Chicago or even nearby Boston, it had then, in the early twentieth century, as it does now, visitors from all over. People coming to Cape Cod for a vacation wanted to be entertained, and the exciting new sound of jazz, which was to soon become America's prime popular music, was certainly entertaining.

Jazz also had the benefit of coming into the American consciousness at the same time as recording technology. In fact, the development of jazz and the phonograph record are virtually parallel. Early phonograph records spread the sound of jazz far and wide, even to seaside hamlets like Hyannis, Chatham, Provincetown, Buzzards Bay, Falmouth and other points on Cape Cod.

In the 1920s, jazz was being danced to in places such as Bournehurst-on-the Canal in Buzzards Bay.

By the 1940s, jazz was heard at the Panama Club in Hyannis, among other places. By the 1950s, the Southward Inn in Orleans was attracting college kids interested in the traditional jazz revival then going on. Also in the '50s, the Atlantic House in Provincetown and Storyville in Harwich were presenting internationally known jazz artists. In the 1970s and '80s, The Columns in West Dennis was the top spot, with competition from the Asa Bearse House in Hyannis, the Captain Linnell House in Orleans and others. In the 1990s, the Roadhouse Café in Hyannis emerged as a great place for jazz.

Add the growth of commercial radio to the mix, and jazz could find its way even into the homes of those who would never set foot in a nightclub or resort hotel ballroom.

Cape Cod would not have its own radio station until the 1940s, but Cape Codders could tune their radios to Boston stations beaming in from across Cape Cod Bay to the north and New York stations coming across Nantucket Sound from the south. By the 1970s and '80s, as radio stations proliferated on the Cape, some would become beacons for jazz, sending the music out to audiences as far as their FM signals would reach.

In short, Cape Cod was as likely as any place in the United States to welcome the new and exciting form of music. But what is surprising is that Cape Cod would develop a de facto jazz colony that would span decades and generations of musicians.

World-class jazz players, including Bobby Hackett, Dave McKenna, Ruby Braff and others, would choose to make Cape Cod home, and many others, perhaps less well known on the international scene but still supremely talented, would join them, giving sandy old Cape Cod a continuing flow of fine music for locals and visitors to enjoy. The Cape can claim Marie Marcus, Lou Colombo, Frank Shea, Bruce Abbott, Fred Fried and others as local talent worthy of performing anywhere in the world.

Many of the jazz players who adopted Cape Cod as their home have passed on, to be replaced by younger players who, unfortunately, do not have the luxury of an audience that was raised in the Jazz Age or the swing era with a built-in appreciation of the music.

While Cape Cod is home to fewer jazz spots than in years past, it does still have a strong jazz presence through the annual Provincetown Jazz Festival, the Cultural Center of Cape Cod, the Cotuit Center for the Arts and Wellfleet Preservation Hall—which present jazz artists on a

regular basis—and a small but sturdy number of clubs that offer jazz to enthusiastic audiences.

The jazz scene has changed over the years on Cape Cod, but what has not changed is that there is a core audience of locals and visitors who love this exciting and challenging music.

I want to tell the story of these musicians who made Cape Cod home and of the places where jazz was, and is, played. Like jazz itself, Cape Cod can be a wild place. Cape Codders can be risk-takers, just like those musicians who improvise melodies and rhythms seemingly out of thin air.

There have been many, and many more will follow.

.

The Musicians

MARIE MARCUS

Marie Marcus, the "First Lady of Jazz on Cape Cod," was admired not only for her considerable ability as a pianist but also for helping to keep the music alive on Cape Cod.

That she was also a working single mother in a male-oriented business is almost overlooked in light of her outstanding talent as a jazz musician.

Born Marie Doherty in the Roxbury section of Boston in 1914, she grew up in an extended family that included a lot of musical talent. By age four, she was playing the piano, and as a youngster she began to study seriously. At thirteen, she gave a classical recital at Boston's Jordan Hall and began studies at the New England Conservatory in Boston while still attending high school. In her mid-teens, she secured a job playing the piano on a children's radio program in Boston, *Bill Toomey's Stars of Tomorrow*, where she accompanied other young performers and also had her own featured spot. Her musical talent also extended to tap dancing, and for a time, she was faced with choosing between dancing and playing the piano as a career track. While performing at a Chinese restaurant in Boston, Marie asked the bandleader, Jimmy Gallagher, which path to choose. "He told me I had something special on the piano and that there were girl dancers under every stone. That made up my mind," she said in an oral history in 2000.

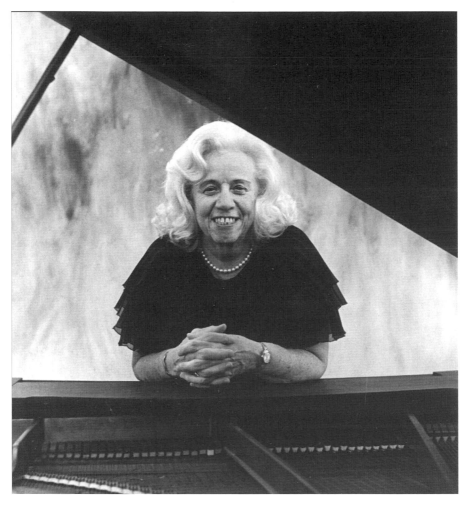

Marie Marcus, known as the "First Lady of Jazz on Cape Cod," in a 1980s publicity photo. *Author's collection.*

More radio work followed, and Marie relocated to New York when her boss, popular radio host Big Brother Bob Emery, got a program on the NBC network there.

Nightclub work followed, including an engagement at Kean's Steak House, co-owned by the mobster Dutch Schultz. While working there, Marie often traveled uptown to hear the bands of Duke Ellington, Chick Webb and others, experiences that would influence her musical life. During a visit to Tillie's Kitchen in Harlem, Marie heard the great stride pianist Fats Waller play. Persuaded to play, "even though I was scared to death,"

she impressed Waller. "When I was finished, he pointed to his heart and said 'For a white gal you sure got it there.'" When she asked Waller to recommend a good jazz teacher, he responded, "How about me?" She began learning from one of the all-time greats.

"You couldn't exactly call them lessons. We'd play duets, and then he'd play and have me listen carefully to the things he did. He was very serious when we were working together, and I was grateful for every minute," Marcus said.

In a 1985 interview with the *Boston Globe*, Marcus recalled Waller saying, "Don't get too busy, and make each note tell a big story. And play the lyrics." This concept of "playing the lyrics," even for an instrumentalist, was key to giving her a strong sense of a song's melody and message.

Marie also recalled that the jazz stars of the era, including Harry James, Tommy Dorsey and Jimmy Dorsey, would come by to hear her play in New York.

"It was almost unheard of for a white woman to play swing music then," she recalled.

In 1937, Marie married singer Jack Brown, and they had a son, but the marriage was short-lived. Fronting her own thirteen-piece band, Marie Doherty and Her Gentlemen of Swing, she had some success, but when World War II began, much of the band was drafted. By 1942, needing a lighter schedule, Marie took a job at the Coonamessett Club in Falmouth on Cape Cod, and thus began a connection that would last the rest of her life.

She recalled arriving on Cape Cod by train. "It was the dead of winter, and I looked around and thought, 'My God I'm in the wilderness.' But within a week my love affair with the Cape began, and I never did get back to New York," she said.

Moving to the Panama Club in Hyannis, Marie often appeared with pianist Alma Gates White as the Piano Mamas. Future president John F. Kennedy would stop by to hear them while he was staying at the family home in Hyannisport.

It was while working at the Panama that Marie met trumpet player Bill Marcus. They married and began working winters in Florida and on Cape Cod in the summer until 1961, when they became full-time Cape residents with their growing family. With her husband taking gigs with various bandleaders, Marie began a successful run as the pianist in a Dixieland band, Preacher Rollo and His Five Saints.

As part of the Dixieland revival of the 1950s, the band recorded for MGM records and worked mainly in the Miami area.

Marie's playing on these records shows plenty of her early stride style, no doubt a Fats Waller influence, as she propels the band.

Preacher Rollo records from this era are somewhat scarce, but they enjoy a long life on the secondhand market and are prized by collectors of old-time jazz.

After suffering a heart attack in 1960, Marie returned full time to Cape Cod, looking for a simpler way of life that would allow her to raise her family while also pursuing her career. With her health restored, she began a remarkable run that would elevate her to status as the leading jazz light on the Cape. Regular gigs followed at Mildred's Chowder House in Hyannis, Ellie's Drift Inn in Mashpee, the Windjammer in Hyannis, the Orleans Inn and many other venues—some remembered, some long-forgotten.

When Bill Marcus died suddenly in 1965, Marie was left to care for her four children, and she rededicated herself to her career. Recordings—and many more gigs, usually at the head of a Dixieland band—followed, and Marie Marcus became a name synonymous with jazz on Cape Cod.

Appearing regularly at venues such as The Columns Restaurant in West Dennis and the Captain Linnell House in Orleans, she also performed solo in concerts sponsored by the Cape Cod Jazz Society.

Taking over as president of the jazz society, Marie made it her duty to promote jazz on Cape Cod. Helping to stage concerts and jazz parties, she was often a featured performer and a favorite of jazz fans who came to know her as a friend as well as a musician.

Of her decision to make Cape Cod home, Marie said, "What makes jazz musicians want to settle down here is the natural, relaxed atmosphere that permeates the entire Cape," according to a 1985 *Boston Globe* report.

Ron Ormsby, who often played bass in Marie's bands and also served as her manager, perhaps knew Marie Marcus better than any other musician. He first met her in 1979 and worked with her for twenty years.

"Marie was a wonderful character. A genuine, heartfelt person," Ormsby said.

Musically, they made an odd pairing, but somehow it worked.

"Musically we hit it off well. I was more into bop and more modern things than what she was playing," but Ormsby kept his ears open and found he could work with Marcus very well.

"She could play traditional jazz, but she wasn't a traditional player as such. She was a swing-Dixieland player. She could be playing Dixieland, then go into stride, and I could exactly duplicate what she was playing," Ormsby said.

Clarinetist Paul Nossiter, who, with George Wein, operated Storyville on Cape Cod for four summer seasons, said it was Wein who introduced him to Marcus.

"He took me to Mitchell's Steak House in Hyannis where she was playing, and I met her. We ended up putting together a band with Charlie Tourjee [trombone] and Jim Blackmore [cornet]," Nossiter said.

"Marie was a wonderful accompanist. It was like sitting in a comfortable chair having her play behind you," he said one afternoon in his Cape Cod living room as he played a recording featuring Marcus, Blackmore, Jim Cullum (bass), Alan Pratt (drums) and himself.

Saxophonist Bruce Abbott called Marie Marcus "sweet and sassy" and said her music was genuine.

"When you'd hear her play you'd say that's authentic, that's the way it's supposed to sound."

Dick Golden, who hosted the *Nightlights* program on WQRC-FM on the Cape for nearly three decades, worked closely with Marcus while promoting various Cape Cod Jazz Society concerts and other events. He would also feature her music on his program.

"Marie was a joyful, wonderful lady whose inner spirit was reflected in her playing," Golden said. "How fortunate for Cape Cod that she moved there."

These days, the Marcus family tradition is maintained by Billy Marcus, Marie's son, who is a successful jazz pianist in his own right.

While Billy Marcus described his mother's piano style as "traditional," he also insisted "she didn't sound like anybody else." He said she learned the stride piano style "the right way," from jazz giants like Fats Waller.

Billy Marcus also said that his mother was not his piano teacher beyond his first lessons. He studied with a succession of talented teachers and developed his own style in modern jazz rather than the more traditional style of his mother.

Still, he says his decision to make music a career is largely due to his mother's influence. "She gave me a shove, because I didn't think I was ready for it," he said.

Marie's funeral in 2003 featured a New Orleans–style procession to Island Pond Cemetery in Harwich, with a six-piece band playing all the way.

The *Cape Cod Times* story about her funeral carried the headline "Swinging in Heaven."

LOU COLOMBO

Lou Colombo might have played big league baseball if an injury hadn't ended that dream while he was still in the minor leagues. But, with his baseball dream dashed, the young man turned to his other great talent:

playing the trumpet. And the jazz world, particularly the Cape Cod jazz community, was the better for it.

Lou Colombo was not a native Cape Codder, but he adopted the Cape as his home and was, in turn, embraced by the Cape community as much for his powerful, swinging trumpet playing as for his good nature and willingness to help others.

Dick Golden, longtime host of the *Nightlights* program on Cape Cod radio stations, recalled Colombo as "a force of nature." In 2012, Golden, who emceed many Colombo performances, said the artist was "one of the most consistent, joyful people I've met. He found so much satisfaction in making other people happy." In fact, Colombo could often be found performing at charity events and senior centers for little or no pay. Performers of his stature can pick and choose their gigs, but Colombo often chose to entertain those in his own community who needed some joy in their lives.

"The guy would play at a nursing home or senior center with the same spirit with which he played alongside Dizzy Gillespie." Golden's reference to Gillespie is not random. For years, a story was repeated that Colombo was a favorite of Gillespie, who was perhaps the leading trumpet star of his generation. Golden confirms its veracity. He recalled going to Gillespie's hotel room to interview the trumpeter for his radio program. As Golden

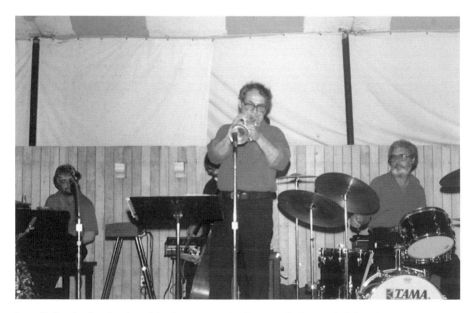

Lou Colombo leads a band in the tent at the famous Columns in West Dennis. *Ron Ormsby collection.*

walked into the room, Gillespie was making a phone call. "I'm calling the best trumpet player in the world, Lou Colombo," Gillespie said. "Do you know him?"

On another occasion, during a performance in Provincetown, on the tip of Cape Cod, Gillespie called Colombo up from the audience to jam with him onstage and repeated his praise for Colombo's playing.

Lou Colombo was born in 1927 in Brockton, Massachusetts, about forty miles from Cape Cod. An outstanding high school baseball player, he was signed by the Brooklyn Dodgers and later played in the St. Louis Cardinals minor league system. A severely fractured ankle prevented him from advancing in baseball, and he slid seamlessly into a career in music, often in the company of saxophone and clarinet virtuoso Dick Johnson, also a Brockton native. The two formed a lifelong musical partnership and performed hundreds of gigs together.

A long-term gig at the Mill Hill Club in West Yarmouth convinced Colombo to relocate his family to Cape Cod in the early 1970s, and from that point on, the Cape was his base of operations. Colombo was a fixture at Cape Cod nightspots, including the Velvet Hammer in Hyannis, where he often shared the bandstand with pianist Dave McKenna. He recorded a now-classic LP, *An Evening at Johnny Yee's*, in West Yarmouth. Jazz fans still covet their copies of that disc. The cover reads: "Presenting Lou Colombo & Dick Johnson, Featuring Dave McKenna, The Magnificent Seven." It also sports a corny photo of Johnson and Colombo digging into a massive Chinese food feast while Yee and two restaurant hostesses look on approvingly.

Gillespie spoke about Colombo with Eric Jackson of Boston's WGBH-FM in 1988:

> *Lou Colombo is what I would call a trumpet painter, he resolves. He starts playing and the notes keep going, but the chord keeps changing all the time. He's a marvelous trumpet player. I went one night to hear him play. Boy, he asked me to play with him and I said "No—you got it, Brother. I'm not going to jump into that hot water." Lou's pretty weird the way he plays because he plays with just one hand. He plays the valves with his right hand but doesn't hold the horn with his left hand. This guy's amazing. I've been preaching his name ever since that night I first heard him down on Cape Cod.*

As a jazz player, Colombo was somewhat of a rarity. He could play convincingly in styles ranging from traditional and Dixieland to the blues and

bebop. And he could make all of those styles swing. Playing with his mouthpiece slightly off-center and usually holding his horn with the unorthodox one-hand style that makes trumpet teachers and purists cringe, Colombo violated some technical rules of trumpet playing. But his legion of fans didn't care about that. They enjoyed his clear, clean tone and his ability to make any tune interesting, usually improvising not too far from the stated theme.

"Play the melody. People want to hear the melody," jazz saxophonist Greg Abate recalled Colombo saying. In addition to many Cape Cod gigs, Abate played with Colombo when both were members of the Artie Shaw orchestra when the band was led by Dick Johnson in the 1980s.

Cape-based saxophonist Bruce Abbott got many of his first Cape Cod gigs with Colombo's band, and he was immediately impressed at how Colombo was able to win over and entertain any audience. Abbott said, "If you were deaf and couldn't hear a note Lou was playing, you could enjoy just watching him work with an audience."

Abbott said at one of their first gigs together, Colombo asked him to pick a tune to play. Abbott chose "The Girl from Ipanema," which he had practiced extensively. "First I played a solo, then he played. And I realized I'd better go back and learn that tune again."

Abbott's admiration even extends to Colombo's grasp of baseball. He described watching a World Series game on television with him and listening to Colombo's running commentary: "That was as good as playing jazz with him. He knew the game so deeply."

Colombo's skill on the baseball diamond is a matter of record. In fact, he may be the only person whose career is chronicled both in jazz encyclopedias and on Baseball-reference.com.

For the record, Colombo's minor league statistics show he first played in Newport News in the Piedmont League in 1945. Stops along the baseball trail included Mobile, Columbus, Houston and Miami, never higher than double-A affiliates. He hit forty-three minor league home runs over his seven seasons.

After Colombo's death, Harris Contos, former president of the Cape Cod Jazz Society, recalled that now-famous Johnny Yee's record and how, many years after it was recorded, he brought a copy of the LP to one of Colombo's gigs for an autograph. When Contos told Colombo the record included one of his favorite songs, Duke Ellington's "In a Mellow Tone," Colombo made it a point to play that song.

"It just shows you that he was a warmhearted guy who enjoyed his audience," Contos said.

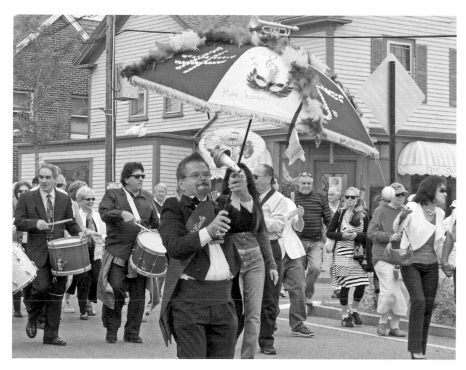

A traditional New Orleans–style funeral parade was held in honor of Lou Colombo. *Photo by the author.*

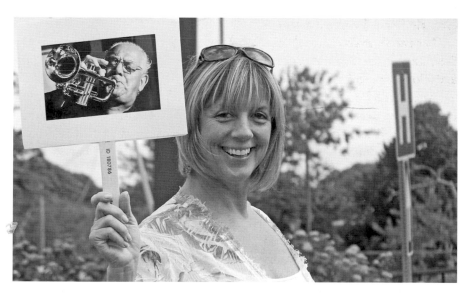

A fan shows her appreciation of Lou Colombo at the parade held in his memory. *Photo by the author.*

In the years leading up to his death in a car crash in Florida at age eighty-four in 2012, Colombo often appeared at the Roadhouse Café in Hyannis, a popular restaurant owned by his son, Dave. The Roadhouse developed a reputation as a place where jazz lives on Cape Cod and where musicians feel comfortable dropping by to sit in with the house band.

On Father's Day 2012, about three months after his death, Colombo was honored with a traditional New Orleans–style funeral procession. Hundreds of Colombo's friends and fans turned out to march along Main Street in Hyannis to the sounds of New Orleans jazz played by a band of musicians from Colombo's wide circle of friends.

The parade ended at the Cape Cod Melody Tent, where a tribute concert and jam session were held for an overflow audience. Lou Colombo would have loved it.

DAVE McKENNA

Dave McKenna followed a somewhat traditional route from his childhood in Woonsocket, Rhode Island, to the highest reaches of the jazz world, and he achieved most of his musical success while living—and performing often—in his adopted Cape Cod.

McKenna's talent as a piano player was evident early. Taught primarily by his mother, by age twelve, he was performing around his hometown, and at fifteen, he was good enough to become a member of the musicians' union.

Before he was twenty, at a time when the big-band era was waning and bebop was becoming the dominant jazz style, McKenna held the piano chair with Charlie Ventura's band. He moved to Woody Herman's band in 1950 and stayed with Herman until he was drafted. The U.S. Army failed to appreciate McKenna's musical talent and assigned him to serve in Korea as a cook.

Resuming his career after his service in the army, McKenna rejoined Ventura and spent the '50s working in the bands of jazz luminaries Gene Krupa, Stan Getz, Zoot Sims and others.

In the 1960s, McKenna began a long musical association with another musician who would also make Cape Cod his home, trumpeter Bobby Hackett. McKenna and Hackett played what Hackett called "Whiskeyland" jazz, often at Eddie Condon's club in New York, a bastion of traditional jazz.

Internationally known jazz pianist Dave McKenna made Cape Cod his home. *Author's collection.*

With his wife, Frances, known as "Frankie," and their two sons, McKenna became a Cape Cod resident in 1966, and with the move to the Cape came a change in McKenna's musical approach. He became less of a band pianist and more of a solo piano practitioner. It was playing solo that he would achieve his greatest recognition.

In a 1979 profile published in the *New Yorker*, Whitney Balliett reported that McKenna had lived on Cape Cod for years, "but he has only been in the ocean once."

Balliett also described McKenna as a homebody. "He lives a quiet, unswinging middle-class life made up largely of eating, playing rumbustious

Ping-Pong with his sons, Steven and Douglas, and watching sports on television—particularly the Red Sox who have been with him all his life."

Cape Cod jazz fans were lucky to have Dave McKenna at the peak of his musical powers. In the 1970s, McKenna was the featured attraction at The Columns in West Dennis, a rambling place that resembled a southern plantation home more than it did a typical Cape Cod building. The Columns was then operated by Warren Maddows, who sometimes joined McKenna to sing a few songs at the close of business. For one summer in the late '70s, Maddows installed a second piano, and McKenna was joined by Teddy Wilson, who had risen to fame as the piano player in Benny Goodman's trios and quartets in the 1930s and is also remembered as one of the swingingest of piano players. With each pianist playing a set on his own, then engaging in inspired two-piano duets, audiences were hearing the kind of jazz usually reserved for big-city nightclubs or concert halls.

After Maddows's untimely death, McKenna moved on to other Cape Cod nightspots, including the Lobster Boat in West Yarmouth, where he kept up his tradition of solo piano, joined occasionally by singers or others who sat in for brief spells.

McKenna's aversion to celebrity and his extreme sense of modesty about his musical abilities tended to keep him out of the national spotlight.

Jim Julian, a Cape Cod jazz fan and a lawyer who did some work for McKenna on occasion, said McKenna's fame never matched his talent. "He just didn't have very good management," Julian said. "He should have been on the level of George Shearing [a pianist who sold millions of records]."

Julian also remembered road trips with McKenna, who never learned to drive a car. Julian said he drove McKenna to gigs in Vermont several times. "He loved the road. He could be himself. He could eat his way through anything," Julian said.

It sometimes took a great deal of effort to get McKenna to show what he could do. Hank O'Neal, the founder of Chiaroscuro Records and a major figure in the world of jazz, recalled in a 2016 interview that McKenna almost didn't record for his label. During an engagement in New York, O'Neal visited McKenna's hotel room: "I put five brand-new $100 bills on the piano at my recording studio and said, "If you want them let's go down and make a record."" Mc Kenna took the bait and ended up recording three solo piano records for Chiaroscuro as well as others as a sideman.

O'Neal recalled that McKenna would say he didn't know any songs as an excuse for not recording, a statement many found laughable, as McKenna was famous for his repertoire of obscure and well-known songs.

In the 1980s, performing up to ten months a year at the Plaza Bar at the Copley Plaza Hotel in Boston while maintaining his Cape Cod home, McKenna attracted the attention of critics who praised his driving, yet swinging, style. Celebrities from the show business, political and sports worlds were regulars at his gigs.

Of particular notice was McKenna's strong left-hand bass lines, a trait he said he developed as a young musician when there was a shortage of bass players. McKenna was also legendary for stringing together medleys of songs built around a particular theme. He would choose a month of the year, a season, the rain, flowers, a person's name— whatever was on his mind—and take his listeners on a musical journey.

Self-deprecating to a fault, McKenna shrugged off much of the critical praise he received. "I play saloon piano," he was fond of saying.

With an increasing string of solid recordings under his belt, McKenna became a musician's musician, known and admired within the jazz community even if his was never a household name.

Saxophonist Bruce Abbott said McKenna was one of those rare musicians who seemed to have a "wrong note filter" to guide his playing. "I wouldn't change a thing about what he played."

By the turn of the twenty-first century, however, diabetes and carpal tunnel syndrome had taken a serious toll, and McKenna's playing was severely reduced. Moving to Providence, Rhode Island, he was off the jazz scene. Compounding his health problems were troubles with the Internal Revenue Service.

"As with many musicians, particularly the older players, royalties from recordings were never plentiful and often do not continue with reissues," Nat Hentoff wrote in a 2002 article about McKenna in the *Wall Street Journal*. Hentoff quoted McKenna as saying, "I wake up at two in the morning wondering when I'm going to be penniless."

Dave McKenna died of lung cancer in October 2008, leaving a recorded legacy that includes dozens of first-rate recordings, mostly of him playing solo piano with that inimitable style. And many on Cape Cod remember when Dave McKenna was their own hometown hero.

BOBBY HACKETT

Standing about five feet, four inches tall, Bobby Hackett nevertheless became a giant in the world of jazz. His mellow cornet (the trumpet's slightly smaller

brother) sound graced thousands of recordings with big bands, lush orchestras and small jazz groups. He grew up in Providence, Rhode Island, performed around the world and lived on Cape Cod for the final years of his life.

Hackett studied the violin, ukulele, banjo and guitar as a youngster before hearing Louis Armstrong and settling on the cornet at his instrument of choice. But when he quit school to pursue music as a career, it was as a twelve-dollar-a-week guitarist with a band in Providence. Hackett worked around the Boston area quite often early in his career and went to New York primarily as a guitarist. After joining Glenn Miller's big band, Hackett put down his guitar and picked up his cornet to contribute the now-famous twelve-bar solo on Miller's big hit "A String of Pearls," recorded near the end of 1941. After that, he was almost exclusively a cornet player (later switching to trumpet at the urging of his musical hero Louis Armstrong).

In the 1950s, Hackett recorded a string of albums under the supervision of Jackie Gleason that became big sellers in the easy-listening field, although Hackett always brought a jazz sensibility to the material at hand. While Gleason made a lot of money from the records, Hackett made far less. According to Hackett's son Ernie, Hackett signed a contract giving him a lump sum of money up front in lieu of royalties. So, although his name appeared on a long list of albums as the featured performer, his take was nothing like what it might have been. However, Ernie Hackett said, Gleason wasn't to blame, and his father made a decision that allowed him to buy a house for the first time with the money he received up front.

Despite dealing with alcoholism and diabetes, Hackett forged a stellar career, and in 1971, he moved with his wife, Edna, to Chatham on Cape Cod.

"He is a born-and-bred city slicker who lives in the woods on Cape Cod," Whitney Balliett wrote in an interview with Hackett published in the early 1970s. Balliett described Hackett as having rebounded from earlier health problems.

"You know this place is something," Balliett quoted Hackett as saying. "The air and the privacy and the quiet get to you. I fell in love with the Cape when I first played here, thirty-eight years ago."

That first Cape Cod gig for Hackett was in the band of Payson Re at the Megansett Tea Room in North Falmouth. That band also included the great clarinetist Pee Wee Russell, and while Re was known primarily for playing polite music for society events, it must have been a swinging ensemble.

Hackett secured a long-term gig at Dunfey's in Hyannis, usually with another Cape Cod resident, the great pianist Dave McKenna, in his band. For a time, Ernie Hackett was the drummer in the band, a challenging

experience for a young drummer just out of the army performing with some of the top jazz players.

"It was a bit nerve-wracking. If I was varying the beat, Dad had a way of stamping out the tempo on the floor with his foot," Ernie Hackett said. He added that while the lessons on the bandstand could be intimidating, they helped him become a better drummer. "I became a great timekeeper, and I thank him for it."

A June 1974 newspaper advertisement offered one dollar off the regular admission price of two dollars at Dunfey's in Hyannis. "Now available for Cape residents only a special membership card so you can enjoy the greatest jazz on the Cape...the Bobby Hackett Quintet...six nights a week," the ad said. It also touted free admission for the weekly Monday-night jam sessions. Those were swinging days on Cape Cod.

Ernie Hackett recalled playing gigs at The Columns in West Dennis and the Wequasset in Harwich with his father's band, a treat for locals and visitors who appreciated world-class jazz.

Bobby Hackett was so enamored of Cape Cod that when he started his own record label he called it Hyannisport Records, in tribute to the village

A band made up of Cape Cod's top jazz musicians played at Bobby Hackett's funeral in 1976. *Frank Shea collection.*

where he worked often and where the Kennedy family had its summer home. Even before he became a Cape resident, Hackett performed often at the Yachtsman in Hyannis, which was a particular favorite of members of the press and White House staff during the Kennedy years.

"Dad always loved the Cape," Ernie Hackett said. "Even when we lived in New York City, he would always book a month or two up there, and we always had a ball."

Hackett's time on Cape Cod would not be long, however. He died in 1976 at age sixty-one and is buried in Seaside Cemetery in Chatham. Funds were short at the time of Hackett's death, and his grave went without a headstone for a year until the Cape Cod Jazz Society raised the money to purchase one and have it installed.

Hank O'Neal, founder of Chiaroscuro Records, was a friend and fan of Hackett and put together a band for a Hackett recording session that haunts him. O'Neal hired Bob Wilber to write arrangements of songs associated with pianist Teddy Wilson. The band would include Hackett, Wilber, Wilson, trombonist Vic Dickenson and bassist Major Holley. O'Neal said Hackett called him from his Cape Cod home two days before the recording session and said he was healthy and ready to record. But Hackett died that night. The album was ultimately recorded with trumpeter Harry "Sweets" Edison in place of Hackett, "but it changed the flavor of the date considerably," O'Neal said.

O'Neal also recalled one time when Hackett's diabetes flared up and the musician had to be treated at Cape Cod Hospital in Hyannis. Hospital staff reported that the phone lines were kept busy with people inquiring about Hackett's condition and wanting to speak to him. The only time they recalled getting more calls about a patient was when the young John F. Kennedy was hospitalized there in the days before he was president.

As a tribute to Hackett, Cape Cod artist and cornet player Gordon Brooks organized annual gatherings at Hackett's grave site where Brooks would play a Hackett solo he had memorized. This tradition went on for many years, until time also overtook Brooks and many of the others who made the yearly visit to the grave of a great musician who chose Cape Cod for his final home.

DICK WETMORE

Multi-instrumentalist Dick Wetmore lived a raucous existence as a jazz musician in Boston and New York before making Cape Cod his home. His

Dick Wetmore played cornet and violin and was a key figure in Cape Cod jazz. *Jack Bradley collection.*

story is one of overcoming adversity and finding contentment in his music on Cape Cod.

Wetmore, who started out as a violinist and recorded a highly regarded album on that instrument in the mid-1950s, was also known later in his career as a cornet and trumpet player working in a style that incorporated traditional jazz but was very much tuned in to more modern sounds as well.

Wetmore was a pioneer of the jazz violin and "might well be considered the first truly modern jazz violinist," according to the Institute of Jazz Studies *Greatest Jazz Recordings of All Time*, published in 1983.

Attending high school in Newton, Massachusetts, a suburb of Boston, Wetmore began his musical education on the violin. After enlisting in the U.S. Army in 1945, he taught himself to play the trumpet so he could play in military bands. Upon discharge from the army, he began working in New York as a trumpet player and, after returning to Boston, enrolled in Boston University as a violin major. He later transferred to the New England Conservatory and resumed playing in Boston and New York on a variety of instruments. Wetmore became a member of the Vinnie Burke String Jazz Quartet, which became the house band for the *Tonight Show* when Ernie Kovacs was the program's host in the early days of television.

Throughout his years working in major jazz venues, Wetmore played summer gigs on Cape Cod often throughout the 1950s at the Southward Inn in Orleans in Leroy Parkins's Excalibur jazz band.

Parkins's family owned a summer home in Orleans, and he and Wetmore were acquainted from Boston. Wetmore's great-nephew James Wetmore conducted an extensive interview with him in 2002 in which Wetmore discussed his life in and out of music. In that interview, Wetmore said Parkins—who was a graduate student when they met and would ultimately earn a doctorate in musicology and have a long career as a record producer—used another trumpet player for the first couple of summers but brought Wetmore in to play trumpet starting around 1952. "And Leroy, to have something to do in the summer when he was away from college (rather than just hanging around down there, because he was more a studious type person than sailing or swimming or any of that), he approached the owner of the Southward Inn and offered to bring a band in."

That band made a record in 1956 called *Southward Session*, but it was produced in-house by the Southward Inn and therefore had little distribution. It was for sale at the Southward to customers who wanted a souvenir of their visit. Today, copies of that disc are sought after by collectors.

Wetmore recalled the lineup of that band: Bob Pilsbury, on piano; Al Ezer, drums, later replaced by Tommy Benford; and Cas Brosky, trombone. Parkins played saxophone and clarinet.

Other musicians passed through the band during its years on the Cape. Of this group, Benford was the one with the most interesting story. Born in 1905 in West Virginia and raised in an orphanage where music was emphasized, Benford performed and recorded with some of the early jazz

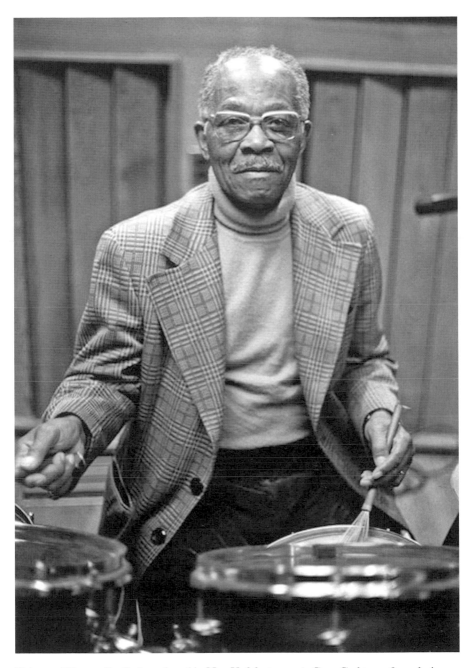

Drummer Tommy Benford was based in New York but came to Cape Cod to perform during the summer in the 1950s in the Excalibur band with Dick Wetmore. *Photo by Hank O'Neal.*

stars, including Jelly Roll Morton, Sidney Bechet and Coleman Hawkins. He made his way first to New York and then went to Boston, where he befriended some of the musicians who would make up the Excalibur band. Benford was on the Cape Cod jazz scene for many summer seasons and one of the few black musicians to work regularly on Cape Cod in the '50s. A variant of the Excalibur band continued to perform into the 1960s, after Parkins left it, under the name the Fog Cutters.

In a 1996 article published in the *Cape Codder* newspaper, Chandler Travis (writing under the byline Thurston Kelp) described the band: "There was nothing high-brow or cutting edge about the Excaliburs—they played loud, jumpy Dixieland jazz the tourists could get hopped up to—but they were all excellent musicians, and it was an integrated band, which was unusual for the time."

Other top-name jazz stars played at the Southward, including Zoot Sims, Gerry Mulligan, Dave Lambert and Mose Allison, but the Excalibur band had the distinction of holding down the regular Sunday afternoon slot.

Wetmore recalled the Southward as a "very sedate" place, except when the Excaliburs were playing there. Much of their audience was college kids spending the summer on Cape Cod.

"The waiters would come out carrying a case of beer and they wouldn't get more than ten or fifteen feet and every beer was gone. And they'd go back and get another case. There were just guys strewn out everywhere, guys climbing up from outside and into the balcony to get into this place."

Wetmore also recalled that the Excaliburs, with Pilsbury fronting the band, performed one summer at the Sandy Pond Club in West Yarmouth, a legendary place owned by Jack Braginton-Smith, who would later own and operate the equally legendary Jack's Out Back restaurant in Yarmouth Port for many years.

Among the publicity stunts pulled off by the Excaliburs was playing in an airplane while flying over Cape Cod beaches. Their wild Sunday performances, which ran from 1:00 p.m. to 1:00 a.m., often included what Travis, in his *Cape Codder* article, referred to as "a little melodrama," in which the owner of the Southward would pretend to shoot Parkins, who was then carried off by two waiters in a makeshift casket while the band continued to play. Later, Parkins "would be lowered from the hay loft in his casket" and burst into song on his clarinet.

It wasn't all good times for Dick Wetmore.

Wetmore was plagued by alcoholism his entire adult life and at times found himself out of the music scene entirely. He moved several times and took jobs outside of music to sustain himself but always returned to jazz.

By the late 1960s, Wetmore was still spending summers on Cape Cod, and while the Dixieland days were over, he entered into new musical partnerships.

Wetmore recalled knowing the artist David X. Young, who at that time was living in Orleans in a studio just above the bar where Wetmore was playing.

"But we used to go up to his place after we'd play in our little bar down below—just a duo, we had a piano and myself. And we'd go up there to Dave's loft after hours and nobody seemed to mind those days about noise. The police station was only about a block away, and they never said anything. And all these people used to come to these after-hours parties up in Dave's loft."

Wetmore recalled the scene in Orleans in the 1950s:

> *There was a photography store down below beside the bar we played in and then two or three other shops. So the loft that was up above had the whole roof. It was as big the whole building down below which was a lot of square feet. It was really big.*
>
> *Norman Mailer and all these people that lived in the lower Cape would show up there at night. And we'd party until daylight—drinking and turning on and the lights are all going weird and ah, Jesus. That went on the whole summer.*

Wetmore led a nomadic life and came to Cape Cod—probably in the summer of 1966—where he rented a garage and took a job painting houses. He bounced back and forth between Cape Cod and Florida with his wife, Barbara, and it was during a brief relocation to Vermont, where his sister lived, that Barbara left Wetmore, literally alone in the woods.

In the early 1970s, Wetmore went to alcohol rehab and began a new path of sobriety. For years, he had been unable to work as a musician because of his alcoholism.

Wetmore's longest-lasting Cape Cod musical collaboration was with guitarist Tom Tracy. Tracy was not a jazz musician when, in the mid-1970s, Wetmore walked into a bar called the Woodshed in Brewster and introduced himself to Tracy and Peter Buscemi, the other half of a duo with Tracy.

Wetmore was told about the Woodshed by a young couple who had befriended him and knew he was a musician.

Tracy was accustomed to amateurs asking to sit in at the Woodshed, and he invited Wetmore to come by some afternoon with his violin to try out some tunes. Tracy recalled the first time they performed together, improvising on a blues.

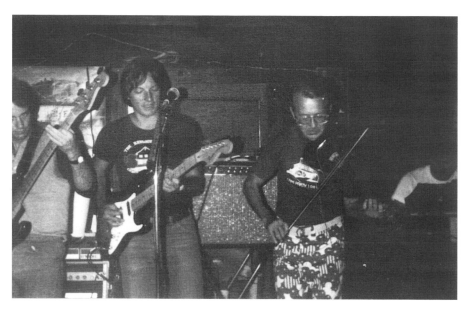

Bassist Peter Buscemi, guitarist Tom Tracy and Dick Wetmore on violin were a popular band on the Cape. *Tom Tracy collection*.

"All three of us started laughing. We just jelled like this organic thing," Tracy said. Wetmore was soon made a regular, appearing Thursday nights with Tracy and Buscemi at the Woodshed, which catered to a younger crowd more accustomed to rock than jazz. Tracy recalled the crowd at first being silent after the first tune, then bursting into wild applause.

Tracy, who had been playing on Cape Cod summers while living in western Massachusetts, became a full-time Cape Codder in 1979, and by 1980, he had formed a duo with Wetmore called Where's Harry. By then, Wetmore was playing cornet as well as violin, and the sound was decidedly eclectic, with Wetmore learning pop tunes and Tracy—twenty years Wetmore's junior—learning jazz tunes. Tracy relocated to Los Angeles for a time to pursue his musical muse but returned to Cape Cod in 1984 and resumed his musical partnership with Wetmore. They performed as a duo and also with a larger group for some memorable gigs at The Columns in West Dennis, among other venues.

As Wetmore's musical rehabilitation continued, he was contacted by his old bandmate Bob Pilsbury, who asked him to join the New Black Eagle Jazz Band—then and now a top traditional jazz group. Wetmore played cornet with the Black Eagles off and on, adding to his reputation as a jazzman.

Wetmore was also approached by Jack Bradley, Cape Cod's famous jazz historian and promoter, who helped to get him additional jazz gigs.

Wetmore recalled performing on the Cape—probably in 1980—and being joined on a gig by the well-known jazz clarinetist Joe Muranyi, who for years maintained a home on the Cape: "Joe was really great. He thought I was dead. Everybody thought I was dead because the way I was drinking I would have been dead. They hadn't heard of me in years, so the story was that I was dead. And Joe played clarinet with Louis Armstrong and came all the way to the Cape to do this thing with me, which was really nice."

Wetmore enjoyed a musical renaissance on Cape Cod.

"So many people remembered me and wanted to see me again because they all thought that I had just gone."

Guitarist, singer and bandleader Chandler Travis recalled those years when Wetmore was making his musical—and personal—comeback.

"There was something childlike in the way he played," Travis said. "It was like he was discovering music again; something he had lost for a long time. It made him fun to play with."

Tracy said Wetmore was "not a mainstream kind of guy" and was always an interesting person to be around.

"He had a glint in his eye that was mischievous and a little smile that went with it," Tracy said.

Wetmore's musical knowledge was impressive to Tracy. "I never had communication with another musician like I did with him," Tracy said in 2016.

Tracy was taken by Wetmore's dedication to sobriety after years of alcohol abuse, and he noted that Wetmore had been sober for years on that day when Wetmore walked into the Woodshed and their partnership began. For a time, Wetmore worked with the Judy Wallace Band, which played music that included blues, R&B, Texas swing, rock and jazz. Saxophonist Bruce Abbott and Wetmore, on cornet, made up the horn section of that popular band.

In the 1990s, at Abbott's invitation, Wetmore became the artist in residence at Nauset Regional High School in Orleans, where Abbott taught music and ran a program on jazz and improvisation for students.

Abbott remembers Wetmore as being a natural teacher who communicated easily with the high school students. Abbott's usual routine was to discuss a piece of music with the kids before performing it, going over the chords and melody to make the students familiar with it. One time he turned the band over to Wetmore, assuming he would take the same approach. But to his surprise, Wetmore simply counted off the tune, and the band began to play.

"With no preparation, he led the kids on a tune that was at least as good as what I did. I guess I was talking too much," Abbott said.

In 1996, Wetmore returned somewhat to his musical roots, performing the music of Jerome Kern and George Gershwin as featured violin soloist with the Cape Cod Symphony Orchestra.

In the 1990s, Wetmore left Cape Cod—the scene of many of his top musical moments—for Florida, where he died in 2007 just before his eightieth birthday.

Tracy said Wetmore had a slogan he often used: "Just keep showing up."

"He was meant to do that," Tracy said.

RUBY BRAFF

A most unlikely Cape Codder, Ruby Braff lived the last twelve years of his life in West Dennis in a small house on a quiet side street.

Born in Boston and largely self-taught on the cornet, Braff was iconoclastic, anachronistic and supremely talented. Known as a difficult personality, Braff had little patience for musicians who weren't up to his standards.

"There was a T-shirt around years ago that read, 'I had a beef with Ruby Braff,'" remembered renowned jazz authority Dan Morgenstern in a 1998 interview. "A lot of people could wear that shirt." But Morgenstern noted that Braff was always "very productive, very prolific."

In Boston, Braff's professional gigs started early. "By the time I was thirteen, I was playing at the Silver Dollar, taking the place of older musicians who would take the weekend off when they got a better-paying gig," Braff said in 1998.

At Roxbury Memorial High School in Boston, Braff refused to play in the school band because he was already a professional and a member of the musicians' union.

His career took him to New York, which was his base of operations from the 1950s through the early '90s. In 1991, Cape Cod became his permanent home. "I'm a New Englander. We have a calling to be near the water," Braff said. "I love the whales and dolphins, just being near the ocean."

Braff's move to Cape Cod was a bonus for the locals, who got to hear him play at Cape venues, usually in the company of top musicians. In May 1992, Braff used an engagement at the Yarmouth Inn as a warmup for a tour of England. Cape stalwarts Bill Davies (piano), Rod McCaulley (bass), Fred Fried (guitar) and Gary Johnson (drums) were his bandmates.

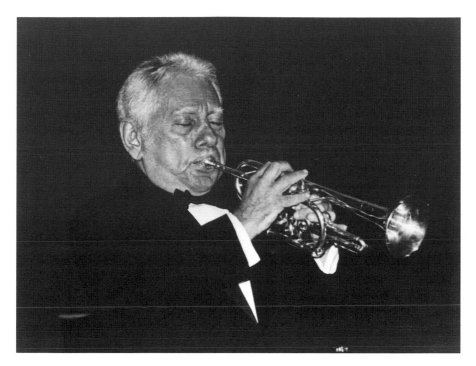

Ruby Braff made Cape Cod his home while performing around the world. *Author's collection.*

In 1994, Braff was diagnosed with emphysema, but he continued to perform. Local gigs included an appearance with singer Donna Byrne at Christine's in West Dennis on the Cape and an early 1995 benefit concert at Cape Cod Community College. A gig at the Regattabar in Cambridge, Massachusetts, saw him playing from a wheelchair, but the music didn't suffer.

Traveling around the world, Braff was a particular favorite in Great Britain, where he performed often, even late in his life when his health was deteriorating.

"I'm a songster," he said, referring to his knack for finding those tunes that best allowed him to express his musical ideas. Indeed, the song was everything to Ruby Braff. The Great American Songbook was the basis for most of what he played; throughout his long career and many recordings, he mined the songs of the Gershwins, Cole Porter, Irving Berlin and the other songwriters, creating brilliant improvisations from their melodies.

So how did this urban denizen and world traveler come to Cape Cod to live?

"I looked at this heavenly piece of land, harbors, boats, those colors. I said why do I have to leave here? Finally, I uprooted myself from New York. New

York was just a mailing address. I was living in a compartment; that's what an apartment feels like to me," Braff said of his life-changing relocation.

Jack Bradley, a longtime friend of Braff's and a resident of Harwich on the Cape, added one more detail to Braff's decision to move to the Cape. Bradley said the relocation was also a chance for Braff to reconnect with a former girlfriend who also had moved to the Cape.

Playing in what has come to be called a "timeless" style, Braff's music was rooted in that of the masters, such as Louis Armstrong and Bobby Hackett (both of whom had strong Cape Cod connections), and remained the same throughout his career. Critics often used words such as "cello-like" to define the gorgeous tone Braff coaxed from his horn. Preferring the cornet's lower register and rarely engaging in musical pyrotechnics, Braff played jazz that was at once thoughtful and deeply swinging.

Like most trumpet/cornet players of his generation, Braff was a devotee of Armstrong and considered Armstrong to be the fountain from which all jazz flowed. Discussing a 1950s television appearance in which he played alongside Armstrong, Braff said, "He let me live," implying that Armstrong could have musically killed him (or anyone else) on the spot, such was his artistry.

Braff's career suffered due to his mercurial personality. The British writer and radio host Steve Voce said in an obituary for Braff that Ruby "was usually abrasive, insensitive, cruel, insulting and…one of my best friends." Voce went on to say that Braff scared away friends and fellow musicians, "as they gave him up in exasperation."

The one time Braff landed a role in a Broadway play, a staging of John Steinbeck's *Sweet Thursday* titled *Pipe Dream* (with a score by Rodgers and Hammerstein), he rebelled at the requirement that he play the same thing every night. The jazzman in him wanted to improvise, but his musical parts had been choreographed for dancers who complained when he didn't stick to the part as written.

Braff's career struggles were also due largely to the fact that he played in a style based in earlier jazz at a time when first bebop and then the cool sound pioneered by Miles Davis dominated. In 1960, Braff said—in a widely reported quote—that he had worked little in the latter half of the 1950s.

But by the time he became a Cape Codder, Braff had become a favorite of the critics and recorded a string of CDs—mostly for the Arbors label—that earned rave reviews.

Like other jazz greats who called Cape Cod home, Braff lived a sort of dual existence, performing in major cities and jazz festivals around the world and returning to quieter Cape Cod to recharge. One of the Cape Cod

musicians who befriended Braff is bassist Rod McCaulley, who played gigs with Braff and helped him as his health declined in his last years.

"Ruby was like a second father to me," McCaulley said. "When my family had tough times, he was supportive, and when he got sick I took care of his business for him." Braff "told me [McCaulley] things I didn't want to hear" about bass playing and connected him with top teachers who helped him improve his playing immeasurably.

McCaulley also said he never got on Braff's bad list because he knew when to stay out of Braff's way, thus extending their friendship. McCaulley was enlisted to drive Braff from Cape Cod to New York for a recording session for Arbors Records in September 2001. They arrived a couple days before terrorists struck the World Trade Center.

"We were on Fifty-Second Street when the towers came down," McCaulley recalled. Braff's band for the recording session had been scheduled to rehearse that day, but that plan was scrapped. Still, with some last-minute personnel changes, Braff made the original recording date with pianist Dick Hyman, guitarist Howard Alden and drummer Jake Hanna and recorded a second album that week with pianist Bill Charlap.

Despite being seventy-five years old and suffering from emphysema, Braff turned in a remarkable performance on the quartet record according to *Jazz Times* magazine, which said, "Braff sounded like a 30-year-old, executing every idea he heard, phrasing with his trademark warmth."

While his name may never resonate with the general public like that of Armstrong, among jazz aficionados, Braff is considered one of the greats, much of his reputation earned while he was a Cape Codder.

BOB WILBER

For a time, Brewster on Cape Cod was home for clarinetist-saxophonist Bob Wilber, who has been a mainstay in the world of traditional jazz for decades.

His connection to the Cape started when his father and stepmother had a summer house in Orleans. In 1977, the *New Yorker*'s Whitney Balliett interviewed Wilber in Orleans and described the musician as thoroughly enjoying his time on the Cape between tours that took him around the world. By 1976, Wilber and his wife, Pug Horton, a jazz singer from England, had their own home in Brewster and spent as much time as they could there, when gigs didn't require them to be elsewhere.

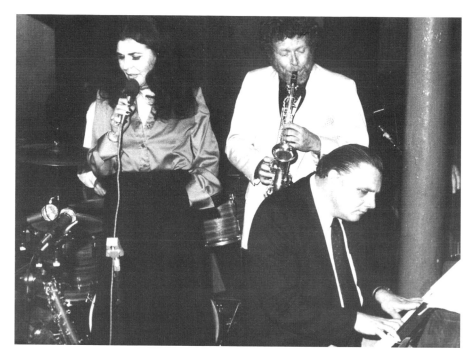

Pug Horton, Bob Wilber and Dave McKenna all made Cape Cod home and performed on Cape Cod and internationally. *Jack Bradley collection.*

Wilber, born in 1928 and raised in Scarsdale, New York, became entranced by jazz at an early age when his father, an amateur musician, would play ragtime piano at home and bring home the latest records by Duke Ellington and others.

By his early teens, Wilber was studying the clarinet seriously. He told reporter Peter Hartley for a 1977 *Cape Cod Times* article that the first time he performed on Cape Cod was in the summer of 1945, when he was seventeen, and played at Jacob's Garden in Chatham.

"They were all dancing the hokey-pokey that summer," Wilber recalled.

Exactly what Wilber performed that summer as World War II was coming to a close is not known, but it seems certain that it was jazz of the classic variety.

"The thing that attracted me to jazz in the first place was just the feeling of the joy to be alive that it expressed. The kind of jazz that will last has that feeling," Wilber told a *Cape Cod Times* interviewer in 1980.

Wilber rejected his parents' wishes that he pursue an Ivy League education. He enrolled briefly in the Eastman School of Music in

Rochester, New York, but, according to his autobiography, left school to "hang out on Fifty-Second Street and in the village."

Wilber became a student of pioneering jazz clarinetist and soprano saxophonist Sidney Bechet, and for a time, he was so immersed in his musical education that he lived in Bechet's Brooklyn home.

Wilber's big break came when Bechet chose Wilber to substitute for him at the first jazz festival held in Nice, France, in 1948. From there, Wilber's career flourished, and he recorded with many of the leading jazz players.

In 1948, Wilber's trio served as the intermission band at the Savoy Café in Boston and was so popular that Wilber expanded the band to a sextet. It became the featured attraction at the Savoy.

Throughout the 1950s and '60s, Wilber maintained the jazz tradition even as the music was moving in new directions. Carving a niche for himself, Wilber was considered a go-to performer in the traditional jazz world. In the early 1970s, he led a band called Soprano Summit and, in the late '70s, fronted the Bechet Legacy Band.

Wilber's international reputation did not preclude him from performing whenever possible in his adopted home of Cape Cod. On New Year's Eve 1978–79, Wilber led a band at the Captain Linnell House in Orleans that featured Horton on vocals, pianist Dave McKenna and Cape-based drummer Frank Shea. A 1978 *Cape Cod Times* article previewing that gig acknowledged the local connection: "The four, all internationally known in the jazz world, are Cape residents but rarely get the chance to work together."

A February 1979 article published in the *Cape Cod Times* summed up the kind of life he led: "The quietly humorous reedman was home in Brewster for a few days recently in between a one night stand in Warsaw, Poland and a weekend at the Central Illinois Jazz Festival."

Around that time, Wilber also found enough hours in the day to record some classical pieces and take on a major project working with the Smithsonian Institution, transcribing great recorded jazz performances and performing them with a repertory orchestra.

In 2015, Wilber and Horton released a two-CD set, *Live from London*, recorded with Dave McKenna thirty-seven years earlier, in 1978. That gig was part of a successful tour that was chronicled in the English music press, as Wilber introduced audiences there to his Cape Cod cohort, McKenna, who had never before been to England.

"By the time he [McKenna] returns to Massachusetts he should have acquired many new admirers here and a measure of local fame," said the British publication *Melody Maker* in May 1978.

In the liner notes to the CD, Wilber wrote, "Dave McKenna has been a part of Pug's and my musical life for many, many years. I worked with Dave and Bobby Hackett on Cape Cod and in New York. We were all so young!"

Wilber went on to say he was "fortunate enough to spend a great deal of time on Cape Cod" and work often with McKenna and Hackett.

One of the tracks on the CD is titled "Wequassett Wail," a tribute to the popular resort on the Cape where they all performed many years before.

Newspaper ads from the late 1970s promoted Wilber and Horton appearing Wednesday through Sunday nights at the Wequassett.

Wilber and Horton were married while they were Cape residents but renewed their vows while on tour in Europe in 1978, according to Pat O'Hare's column in the *New York Daily News* from July 21 of that year: "Wilber and Horton got married onstage at Nice, France. They'd done it in Massachusetts just before they left, but they thought it would be nice to do it again before a big audience."

Michael Zwerin, in a 1979 article for the *International Herald Tribune*, wrote that Wilber "spends as much time as possible on Cape Cod" and that "there is in fact a good deal of New England gentility about him."

The Cape Cod portion of Bob Wilber's career is one of many highlights. In the 1980s, Wilber went on to win a Grammy award for his musical arrangements in the film *The Cotton Club*. He and Pug toured and recorded extensively with the Bechet Legacy Band, and by the 1990s, the couple had relocated to Gloucestershire, England, which became their musical home base.

BART WEISMAN

Drummer, entrepreneur and teacher Bart Weisman may very well be the future of jazz on Cape Cod.

Arriving on the Cape in 2003, Weisman has since become the primary mover behind much of the jazz heard on the peninsula.

Raised in Washington, D.C., Weisman served in the U.S. Air Force and played in the Air Force Diplomats band. In 2003, he relocated to Provincetown with his wife, artist Amy Heller, and soon, Weisman was revitalizing the Cape's jazz scene, which had reached a low point after the demise of the Cape Cod Jazz Society and the tendency of nightclubs to offer either canned music or rock bands, rather than jazz.

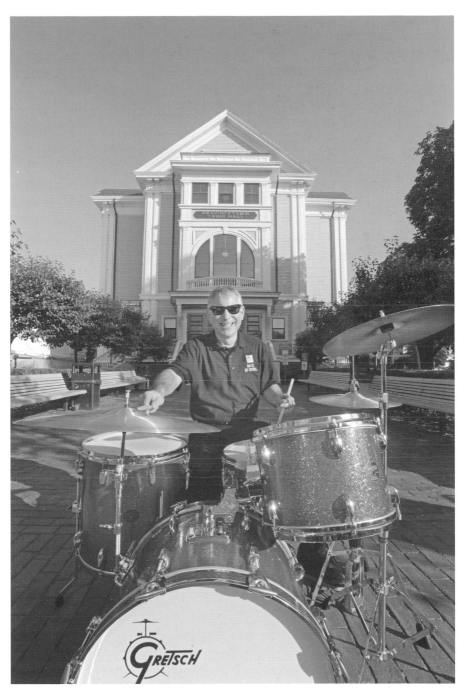

Bart Weisman playing in front of Provincetown Town Hall. He is an accomplished drummer as well as an impresario who runs the Provincetown Jazz Festival. *Provincetown Jazz Festival photo by Jim Preston.*

As a performer, Weisman plays in a variety of settings; a trio, often backing singers or instrumental soloists, the Cape Cod Jazz Quartet, a smooth jazz group and even a klezmer swing group are some of the things he does. "It's a brand," he said in a 2016 interview, noting that the music he presents is the kind of music he would appreciate hearing on a night out.

In recent years, Weisman has taken on teaching duties at the Cape Cod Conservatory and the Sturgis Charter Public School.

Weisman organizes monthly Sunday afternoon jazz jams that attract musicians of all ages and skill levels. It's not unusual to have 25 or more musicians show up to play in various combinations to an audience of about 130 people at the Riverway Restaurant in South Yarmouth.

Weisman tells the story of the day when a clarinet player he didn't recognize showed up and asked to play. When Weisman asked about the clarinetist's musical background, the man replied, "Google me." It turned out to be Joe Muranyi, a former member of Louis Armstrong's band and a part-time Cape Cod resident. It's that kind of musical surprise that can make the jazz jams so rewarding.

But perhaps his best-known achievement is the Provincetown Jazz Festival, held each August at the Cape tip and featuring talent from around the world.

Weisman organized the first festival in 2005, and it has grown to the point where it now also presents concerts in Cotuit about forty miles from Provincetown and offers shuttle bus service to Provincetown from the Cape's hub of Hyannis, to make things more convenient for concert-goers.

Weisman says he has no trouble attracting talent to the festival.

"The waiting list for the jazz festival is long," Weisman said.

In 2006, *Provincetown Arts* magazine quoted Weisman as saying, "Twenty years from now, we can look back on this and say 'we created the Provincetown Jazz Festival.' We all participated in something that is a big ongoing musical event for the town, as the Festival matures." More than a decade in, Weisman had already achieved that goal.

Weisman says the Provincetown Jazz Festival crystalizes his various roles in the Cape's jazz community. He works intensely on the organizational side of the event, but he says that at some point after the musicians have arrived and the audience is seated, he changes gears and becomes a musician again. He can put aside the managerial aspects of what he does and just enjoy playing jazz.

Saxophonist Bruce Abbott, who works often with Weisman in various musical settings, gives Weisman credit for keeping a jazz scene alive on the Cape.

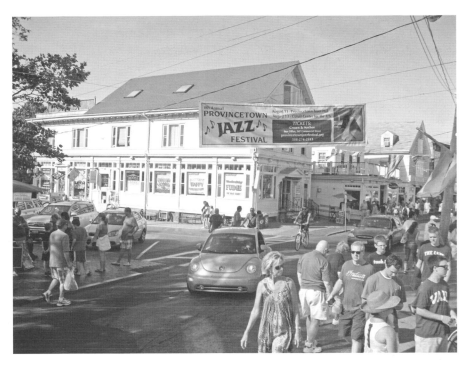

The Provincetown Jazz Festival draws many fans to the Cape tip each summer. *Provincetown Jazz Festival photo by Amy Heller.*

"Bart creates opportunities. We could all take a page out of his book. He's so consistent," Abbott said.

Weisman says he enjoys, and even thrives in, his roles as impresario and teacher, but "at heart I consider myself a drummer."

MUSICIANS AND MEMORIES

John Salerno

Whether leading a big band, playing piano in a trio or performing solo, John Salerno has been on the Cape Cod jazz scene for more than fifty years.

Arriving on Cape Cod in 1960 from his native Worcester, Massachusetts, Salerno plunged into the Cape's musical community with gigs from one end of the peninsula to the other. Salerno lists among his early work a residency at the Christopher Ryder House in Chatham. The Ryder House

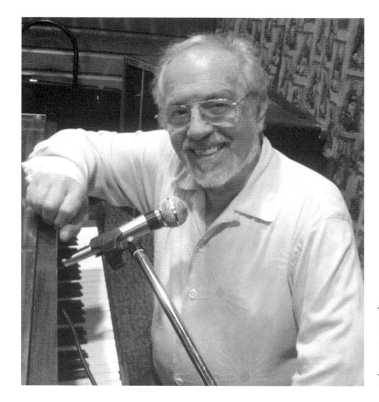

John Salerno has been a popular figure on the Cape Cod jazz scene for decades. *John Salerno collection.*

featured large Broadway-style musical revues every night. It was dinner theater with nonstop entertainment provided by young up-and-coming singers, and his trio played jazz between performances.

Along with extensive work on Cape Cod, Salerno has traveled the world, teaching music in Turkey for a time in the 1960s and performing throughout Europe as a pianist and singer. He served as director of the Cape Cod Conservatory Jazz Ensemble, as a teacher in the Bourne school system and as director of music at Massachusetts Maritime Academy in Buzzards Bay, among many other assignments.

Salerno's career took him to a long stint at Falmouth's Coonamessett Inn, where Marie Marcus had gotten her start on Cape Cod years before. Salerno said the Coonamessett was "probably the best restaurant in Falmouth," but the venue was not known as a jazz club, except when he played there. The John Salerno Big Band recorded an album at the Coonamessett in the 1980s, and its swinging music holds up more than thirty years later.

In the liner notes to that album, the esteemed Boston radio host Ron Della Chiesa placed Salerno in musical context: "Through the years, Cape Cod has been as famous for its jazz heritage as it has for its numerous tourist

attractions. Dave McKenna, Lou Colombo, Marie Marcus and Bobby Hackett have all lived and played there. John Salerno is another musician dedicated to the cause of continuing this remarkable Cape Cod jazz legacy."

In addition to Salerno on piano, the band on the Coonamessett disc includes G. Gordon Eliot, bass; Lee Jones, drums; Dick Andrews, guitar; Jim Miller, Ty Newcomb, George Machon and Manny DeLima, trumpets; Sonny Cain, Rik Aittaniemi, Peter Abramo and Marc Lucier, trombones; and Tony Coelho, Troy Tyson, Mike Crocco, Rich Rubino and Dick Meehan, saxes. It's a powerful and deeply swinging band filled with good soloists.

Salerno became the favorite musician of the Kennedy family and performed often at the Kennedy compound in Hyannisport, often for visiting dignitaries from the United States and abroad.

In 2016, Salerno lamented the dwindling number of spots available for jazz musicians on Cape Cod and recalled a different time: "In the late '60s and early '70s, you could walk along Main Street in Falmouth and there were maybe sixteen or seventeen places where there was live music; not all jazz, but live music," he said. Still, Salerno keeps busy musically and remains in demand for a variety of events.

Billy Marcus

Billy Marcus started his musical life playing the trombone and didn't take up the piano seriously until his teens, but when he did, he quickly showed evidence of a strong family musical heritage. After all, he is the son of iconic jazz pianist Marie Marcus and trumpet player Bill Marcus, who died when Billy was young.

Billy Marcus recalls his first jazz gig, in 1965—the summer he graduated from Dennis-Yarmouth Regional High School—at the Stage Door bar adjacent to the Cape Playhouse in Dennis, one of the top summer theaters in the United States.

"The second night I was there, Bette Davis walked in. I almost passed out. I was eighteen that summer and knew very little musically speaking. It was my first professional gig."

In 2016, Marcus also recalled that after college, he "worked just about everywhere on the Cape" at one time or another.

He, too, misses the many places where jazz was played on Cape Cod a few decades back and recalled a particularly memorable engagement at a long-gone place called Charlie's in the summer of 1971. The main attraction was the

Billy Marcus in a 1980s publicity photo. He carries on the jazz tradition of his mother, Marie Marcus. *Author's collection.*

Treniers, a fondly remembered group that blended rhythm and blues, doo wop and rock and roll. Marcus's job was to play jazz for dancing between sets by the Treniers. He said he was unprepared for the reception. "The place had a huge ballroom, it could hold four hundred people. When the club opened in late June, from day one there were four or five hundred people there a night." Charlie's, however, was destroyed by fire after the season ended and never reopened.

In the '70s, Billy Marcus worked in the band backing trumpeter Bobby Hackett at the Windjammer Lounge in Hyannis. Hackett's son Ernie on drums

and bassist Frank Tate rounded out that band. Marcus recalled that Hackett was often away at other gigs, and talented players, including trumpeter Billy Butterfield and saxophonist Charlie Ventura, were brought in as substitutes. It all added up to a musical education for Marcus, who has been based in Florida for many years. He continued to perform on the Cape summers for nearly a decade before making Florida his permanent base, while still playing the occasional date on Cape Cod. His career has taken him to long engagements at the Ritz Carlton Hotel in Shanghai, China, and the Grand Hyatt in Dubai as well as to jazz festivals in Europe and throughout the United States.

Marshall Wood

Marshall Wood, a bassist whose career reached a high point when he became part of Tony Bennett's band, recalled playing on Cape Cod early in his career.

Wood, like so many young musicians, came to Boston to study at the Berklee College of music and began playing gigs with pianist Joe Delaney. That association took them to Hyannis and a visit to the Snuggery at Bobby Byrne's Pub in Hyannis where jazz was featured in the late 1970s. Wood recalled first hearing singer Donna Byrne there. Little did he know that they would end up married.

Wood recalled Cape Cod as having a vibrant jazz scene then. He performed regularly at the Snuggery; the Captain Linnell House in Orleans alongside pianist Jack Bumer; in Provincetown in a summer jazz series at Town Hall booked by Arnie Manos and Julia Cohen; at Molly's in Falmouth with pianist Eddie Higgins; at Anthony's Cummaquid in Yarmouth Port; and at the Wequassett in Harwich with Billy Marcus.

He remembers an encounter with cornetist Ruby Braff in 1983 during an engagement at the Captain Linnell House. Braff was not yet a Cape resident, just vacationing, and he dropped in on Wood's gig with tenor saxophonist Scott Hamilton and guitarist Cal Collins. "He didn't play that first night, but he came in the second night with his horn," Wood recalled. "Ruby was a little man with a huge presence."

Wood is philosophical about the decline in the number of jazz venues on Cape Cod and elsewhere. He said the generation that grew up listening to jazz during the swing era began to die off.

Those jazz fans were used to music that came from the so-called Great American Songbook, and while that music remains vital, its core audience

Bassist Marshall Wood is at the center of this band: Paul Broadnax, piano; Gray Sargent, guitar; Herb Pomeroy, trumpet; Alan Dawson, drums; and Andy McGee, tenor sax playing at a Cape Cod Jazz Society concert tribute to Duke Ellington. *Photo by John Schram, author's collection.*

has diminished. "It was a generation that went out to dinner at places where they had a nice band and you could dance," Wood said. "Things do change."

For several years starting in the late 1980s, Christine's restaurant in West Dennis, then owned by the Jamiel family, had a Monday night jazz series that often featured top-name players from around the country. Wood performed there accompanying jazz guitarist Charlie Byrd, clarinetist Buddy DeFranco and others. For several years, Wood also booked the jazz talent for Christine's, bringing in such in-demand players as saxophonist-clarinetist Ken Peplowski, trumpeter Warren Vache and saxophonist Scott Hamilton, among others.

Wood was also the bassist in Ruby Braff's group during the final years of Braff's life and recorded several highly regarded albums with him, some featuring unusual combinations of instruments. It is a time Wood recalled as "extremely difficult and extremely wonderful" due to Braff's mercurial personality.

Donna Byrne

Singer Donna Byrne has performed on Cape Cod since 1977 and emerged as one of the top jazz singers in New England. But Byrne didn't start out with an eye on a career in jazz. She recalled visiting a restaurant in Cotuit where Mickey Gentile was the pianist. The audience

was talking and generally ignoring Gentile, so Byrne, who was pregnant with her first child, made it a point to tell Gentile how much she enjoyed his playing. To that point, she had never sung in public, but at Gentile's urging, she did a few songs with him. Gentile then said he wanted her to sing with him after her baby was born, and a month later, he called and hired her to sing with him at the Admiralty in Falmouth.

Other gigs soon followed, and Byrne became a favorite of Cape stalwarts, including Dave McKenna, Dick Johnson, Lou Colombo and others. Byrne credits her interest in jazz standards to her time in dancing school, where she was exposed to the Great American Songbook.

Byrne was married at the time to restaurateur Bobby Byrne, and she opened the Snuggery as a separate music room in his Hyannis restaurant. From 1979 to 1982, Donna Byrne had a regular place in which to perform and also booked other jazz players into the Snuggery.

She recalled her musical partnerships with McKenna, Colombo and others. "I am so blessed. The older I get the more I realize what a gift this was," Byrne said. She said Dave McKenna and trumpeter Herb Pomeroy in particular took her under their wings and encouraged her in her career.

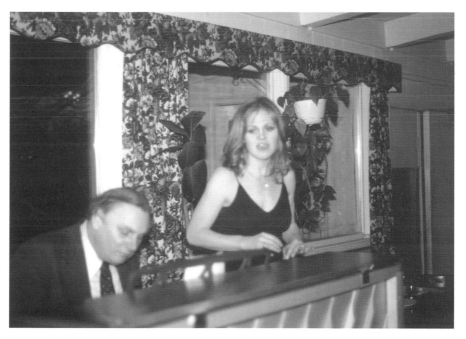

Singer Donna Byrne is accompanied by pianist Dave McKenna at the Snuggery at Bobby Byrne's in Hyannis. *Donna Byrne collection.*

Donna Byrne in a publicity photo. Her career has flourished since her early days singing on Cape Cod. *Author's collection.*

She recalled attending a party in New York at which Tony Bennett was a guest and McKenna insisting that she sing for Bennett. She said she wasn't wearing her contact lenses at the time and therefore was not intimidated by Bennett because she couldn't recognize him.

Byrne also recalled the many Cape Cod night spots where jazz was regularly heard and she performed in the 1980s and '90s, including the Asa Bearse House in Hyannis, Molly's and The Columns, where she often sat in with other musicians.

"The people who owned The Columns [Warren and Beryl Maddows] could not have been nicer. They used to come to hear me at other places where I played," she recalled.

Byrne remembered the jazz scene on Cape Cod as a tightknit community. "Everybody knew everybody in music on the Cape. It was a real familial feeling." She said audiences on Cape Cod seemed more relaxed. "They were plentiful and appreciative," she said.

Ted Casher

Saxophonist Ted Casher began performing on Cape Cod in the 1960s and worked with every prominent jazz figure. Casher's connection to the Cape came through Lou Colombo, who hired him for gigs that included such players as pianist Paul Schmeling, reedman Dick Johnson and drummer Gary Johnson, Dick's son.

Casher also recalled performing at the Mill Hill Club in West Yarmouth with Art Pelosi, a frequent visitor to the Cape from his Providence, Rhode Island home.

Saxophonist Ted Casher chats with friends at the Cultural Center of Cape Cod. *Photo by Bob Tucker, Focal Point Studio, collection of Karyn Hewitt.*

Casher is among the legion of musicians who performed with pianist Marie Marcus and admired her playing. "She was a very dear lady. I wrote a song she liked called 'Walking in Savannah,' which she recorded with Marian McPartland," Casher said.

Bob Hayes

Bob Hayes is a Cape Cod jazz treasure. Since his first gigs on the Cape in 1950, he has been a constant presence on the Cape's musical scene.

His first Cape appearances were at the restaurant adjacent to the legendary Cape Playhouse summer stock theater in Dennis. Hayes would work there during the summer, then head back to his teaching job in New York State. He built his own place, Captain Luther's Locker, where he performed regularly. He recalled in a 2016 interview that because Cape Cod is a summer resort, he never knew who might be in the audience. One night, a waiter told him the top jazz trombonist Kai Winding was in the audience. It turned out Winding had just been married and was on his honeymoon. As any professional musician would, he had his trombone with him, and he agreed to sit in with Hayes's band.

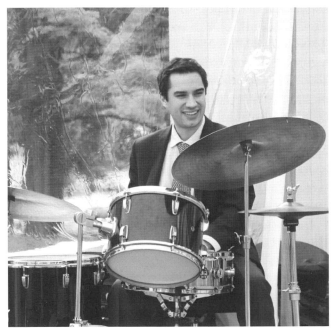

Above: Pianist Bob Hayes is surrounded by members of his band in 1984 (*clockwise from bottom left*): Bob Leech, Steve Ahearn, Mickey Julian, Dennis Nobrega and Charlie Tourjee. *Bob Hayes collection.*

Left: Kareem Sanjaghi is a member of the new generation of jazz musicians on Cape Cod. He got his start playing in the bands of his grandfather Bob Hayes. *Kareem Sanjaghi collection.*

Hayes also recalled performing a number of times at the Rof-Mar, a resort in the woods of Sandwich on the Upper Cape. His band, which included Cape-based trombonist Charlie Tourjee, performed there seven nights a week. Hayes also subbed for Dave McKenna on occasion when McKenna was in New York or Boston on gigs. Hayes, who taught driver education as well as music, once offered to teach the famously reticent McKenna to drive, but McKenna declined the offer.

Hayes recalled jam sessions at the Sandy Pond Club, the legendary spot in the Woods of West Yarmouth, remembered as a roadhouse where people knew how to have a good time.

As for his piano style, Hayes said he is a "melody guy." He likes to "always keep the melody in mind" when he improvises.

Hayes's career has brought him into contact with some of the top names in American show business. He recalled being hired by booking agent Russ Kelsey to perform at a benefit for the first major expansion of Cape Cod Hospital in the 1970s. Kelsey had also booked Bob Hope to perform that night. Hayes says the performance went off without a hitch. Later that year, Hayes was also booked to perform at a benefit for another hospital in Tampa, Florida. And who should be the headliner but Bob Hope. Hayes says Hope walked into the rehearsal, remembered him from the Cape Cod job and told him to skip the rehearsal and come back at show time.

Hayes, in his long career on Cape Cod, worked with every jazz musician imaginable, including Lou Colombo, Dick Johnson and Kenny Wenzel at places like the Wianno Club in Osterville, Mitchell's Steak House in Hyannis and elsewhere. His memories include gigs at the long-gone Jacob's Beer Garden in Chatham, where jazz reigned on Sunday afternoons.

Hayes has been a mentor to his grandson Kareem Sanjaghi, a talented drummer. Sanjaghi credits Hayes with giving him his start in jazz.

"Every successful performance I've had all goes back to my grandfather," Sanjaghi said. Through Hayes, the young drummer met Lou Colombo and performed often with him until Colombo's untimely death.

"The bandstand is the best place to learn," Sanjaghi said.

Greg Abate

Saxophonist Greg Abate has seen his career blossom in recent years to the point where he is now in demand at venues around the world. But early in his career, Abate led a popular jazz-rock band, Channel One,

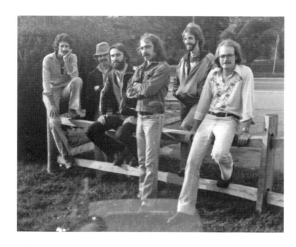

Saxophonist Greg Abate (*center front*) with members of his band Channel One in an early 1980s publicity photo. *Greg Abate collection.*

based on the Cape, and he continues to perform on the Cape as often as he can.

After completing his studies at the Berklee College of Music in Boston in 1971, Abate soon found himself as the lead alto sax player in the Ray Charles Orchestra, touring the country and the world with the singer. One of the hundreds of gigs he played with Charles was at the Cape Cod Coliseum in South Yarmouth, which, in addition to hosting ice hockey games, was an all-purpose venue that was often the scene of concerts by major artists. After two years on the road with Charles, Abate formed Channel One, a six-piece band that combined jazz and rock and became a force on the New England music circuit in the late 1970s and early 1980s. Abate refers to Channel One's music as "creative fusion," and the band had a long-term residency playing Sundays at the Barley Neck Inn in Orleans as well as at other Cape Cod venues when it wasn't on the road.

In addition to Abate on saxophone, the band included Paul Murphy, guitar; Chris Bellomo, drums; Lenny Bradford, bass; Jim Merkin, keyboards; and Tony Allen, drums.

Channel One made a record, *Without Boundaries*, in 1981, which Abate produced. It carried this message: "Dedicated to the earth and all the people in the hope that we will someday live in peace together sharing prosperity united by one channel of positive energy."

Abate said he felt the same attraction to the Cape that other musicians have felt. "The Cape is a little isolated. There's a mentality that supports the arts. There are also tourists from all over the world. People there really have a passion for the arts."

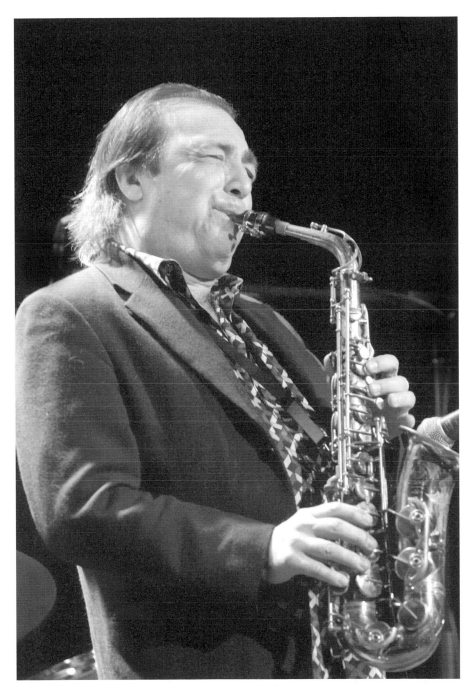

Greg Abate in a recent publicity photo. *Author's collection.*

Abate recalled what he called a "killer gig" working with pianist Joe Delaney at the East End Grille in Hyannis among his favorite Cape engagements.

By the mid-'80s, Channel One had run its course, and Abate signed on as a member of the revived Artie Shaw Orchestra, which by then was under the leadership of saxophonist Dick Johnson, himself a revered jazz figure on Cape Cod.

"Dick Johnson was a big inspiration for me. He had a wonderful sense of the human spirit," Abate said. "Without him I wouldn't play anywhere near the capacity I'm capable of now."

Abate today works in Europe and around the United States in settings ranging from concerts and jazz festivals to nightclubs, but he returns to Cape Cod several times a year for gigs, often at the Cultural Center of Cape Cod or the Cotuit Center for the Arts, that always draw big audiences of new jazz fans and those who remember him from the early days of his career on Cape Cod.

Alan Clinger

He came to practice psychiatry on Cape Cod in the mid-1970s, and while he was at it, he added a second career as a jazz guitarist. For Dr. Alan Clinger, every gig is a "sheer delight."

Clinger, like so many other young men, had learned to play the guitar a bit early in life, but music had to be put aside as he pursued his medical career. He says his wife, Jody, reminded him that he had always wanted to get back into music, so in the 1980s he started studying seriously, first with Richard Andrews on the Cape and then, at the recommendation of trumpeter Ruby Braff, with Howard Alden in New York. He also credits John Wheatley as an effective teacher for him.

Soon, Clinger found himself sitting in with some of Cape Cod's leading jazz players. At a gig with fellow guitarist Fred Fried, trumpeter Lou Colombo came by to jam. When Clinger admitted he really only knew six or eight songs well enough to play in public, Colombo was his usual upbeat self. "Let's play them, then play them again in a different order," Clinger recalled Colombo saying.

"That was my intro to playing. The guys never said a critical word," Clinger said.

Are there parallels between jazz and psychiatry?

"Practicing psychiatry is somewhat improvisational," Clinger said. "Every session has a thread, a theme."

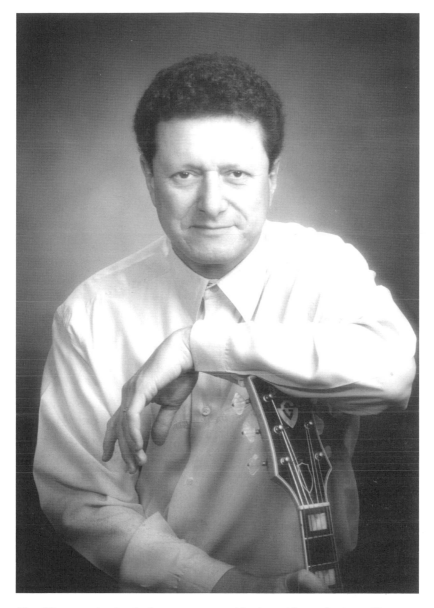

Alan Clinger maintains dual careers as a psychiatrist and jazz guitarist on Cape Cod. *Author's collection.*

As he has reduced his practice, Clinger has devoted more of his time to playing jazz, which still allows for human interaction.

"The thing you learn is to play to your audience; read the room."

Fred Fried

Guitarist and composer Fred Fried is among the group of jazz musicians who is not afraid to try something new and different—from the guitars he plays to the music he writes.

Fried came along as a clarinet player and attended New York's High School of Performing Arts. It was only after he entered Boston University

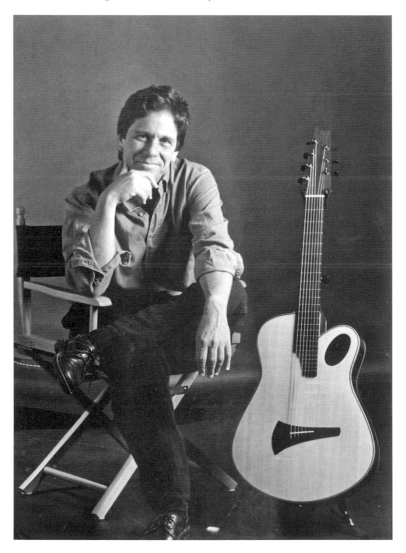

Guitarist Fred Fried is a popular guitarist and composer, usually playing guitars that have more than the standard six strings. *Author's collection.*

that he took up the guitar and knew he had found the right instrument. Fried and his wife came to live on Cape Cod in 1990.

"It's got advantages and disadvantages. I've been fortunate enough to get gigs playing what I want to play, with very excellent musicians," Fried said.

Fried said the first jazz he recalls hearing on Cape Cod was at the East End Grille in Hyannis where pianist Joe Delaney, trumpeter Lou Colombo and saxophonist Dick Johnson, among others, were playing. He thought, "If this is what the Cape is like, I'll take it."

For years, Fried has played seven-string and eight-string guitars. He first took up the seven-string instrument after studying in Los Angeles with George Van Eps, considered the master of the seven-string instrument. These days, Fried often works on an eight-string guitar. The additional strings, he says, allow him to take more of a "pianistic" approach to his music.

Fried also records regularly, which gives his music international exposure from his home base on Cape Cod. "The guitar for me has always been a means toward creating the music the way I would want to hear it. And, at the heart of it, all music is a spiritual endeavor. It's the wordless expression of the human spirit."

Paul Nossiter

Paul Nossiter is from a generation of jazz players who grew up with the sounds of Benny Goodman, Louis Armstrong and Duke Ellington. As a clarinetist and saxophonist, Nossiter has performed in big bands and small, and he has spent most of his long career on Cape Cod.

Nossiter grew up in New York, studied the clarinet with Rod Cless and while still in his teens was performing in jazz clubs, including Jimmy Ryan's in New York. He graduated from Carlton College in Minnesota and pursued a master's degree in education at Harvard University. While attending graduate school in Boston, he organized a Dixieland group that played at George Wein's Mahogany Hall club in Boston in the same building that would also become home to Wein's famous Storyville club.

Nossiter became a schoolteacher in a Boston suburb and, for a time, gave up playing professionally. He did, however, remain friendly with Wein. With his wife, Nossiter had already become a part-time Cape Codder and knew the area well, and when the impresario asked him to join him in opening Storyville Cape Cod in 1957, Nossiter returned to the world of jazz.

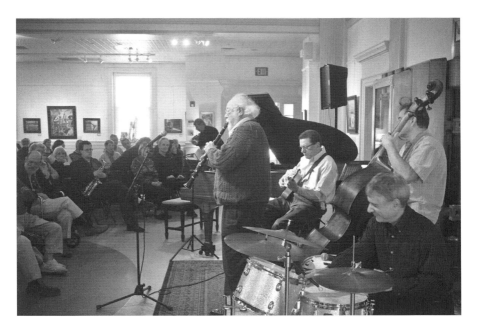

Paul Nossiter, on clarinet, performs for an audience made up mainly of other jazz players on Cape Cod's Great Jazz Day in 2012. *Photo by Bob Tucker, Karyn Hewitt collection.*

Although Storyville on the Cape was relatively short-lived, it helped to cement Nossiter's relationship with the area. He worked as a teacher at private and public schools and has been a regular on the Cape, working with other local favorites, including Marie Marcus, Lou Colombo and many others. Nossiter has retained his love for classic jazz. When asked to describe his style, he said, "There's a lot of Benny Goodman in my playing."

Well into his eighties, Nossiter keeps up a busy schedule. Following the untimely death of clarinetist-saxophonist Lee Childs in 2012, Nossiter assumed leadership of Childs's Bourbon Street Paraders, a small group dedicated to traditional jazz. His playing has evolved over many years: "I play Dixieland, but in a much looser style than when I was eighteen or nineteen," he said.

Lee Childs

A devoted interpreter of early jazz, Lee Childs was one of the busiest musicians Cape Cod has ever seen—and one of the most popular.

Childs, who died in 2012 at age sixty-six, was playing in a Dixieland jazz band by the age of twelve in his hometown of Wellesley, Massachusetts.

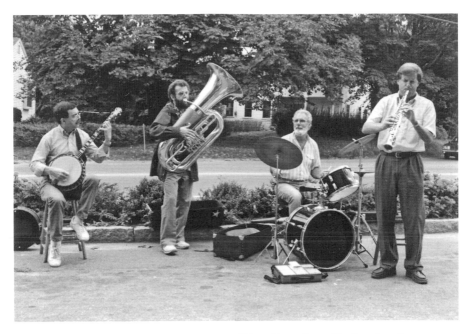

Lee Childs (*right*) was primarily known as a traditional jazz player. His Bourbon Street Paraders were a popular attraction, often performing on cruise boats on the Cape Cod Canal. *Frank Shea collection.*

After studying at Cornell University and Boston's Berklee College of Music, his career took off. Relocating to Yarmouth Port on Cape Cod with his wife and children, Childs worked in various musical combinations, most often with his own band, the Bourbon Street Paraders. As the band's name would indicate, this group was dedicated to traditional jazz, right down to the inclusion of a tuba and banjo, instruments rarely used in more modern styles of jazz.

Drummer Frank Shea, who worked in Childs's band often, said Childs taught him a great deal about traditional jazz, something Shea had not had much exposure to. "I was never much into traditional jazz, but when I started playing with Lee I realized how happy that music was," Shea said.

Childs's band recorded often and was in demand at events ranging from old-time picnics to concert performances. A longtime gig for the Paraders was playing on Cape Cod Canal cruise boats, where the band's style of music made the perfect accompaniment to a summer day on the water.

It was a sign of the respect and admiration Childs earned that his many friends got together for a musical tribute to him in June 2013 at the Lighthouse Inn in West Dennis, overlooking Nantucket Sound.

Childs's friend and saxophonist Ted Casher led a band that included Paul Schmeling, piano; Phil Person, trumpet; Gary Johnson, drums; Laird Bowles, bass; Michael Lavigniac, banjo; Stu Gunn, tuba; and many others.

As a special tribute, Childs's wife, JoAnne, hired an airplane to tow a banner over the beach where his tribute was being held. "Think of me. We hear you Lee Childs. Forever!" it said.

Frank Shea

Growing up in Connecticut, Frank Shea was transfixed by the big bands that would come to his native Bridgeport. As a youngster of nine or ten, he would find his way to the theaters where the bands were playing and immerse himself in the sounds of the swing era.

His heroes were the drummers who drove those big bands, and he learned a lot from them. By the time he was in his teens, he was starting his own career as a drummer with bands large and small.

Shea's musical outlook expanded to include the bebop sounds that changed jazz in the 1940s and '50s, earning him the nickname of "Bebop Shea," which was bestowed upon him by a radio disc jockey. His career took him to Los Angeles and Chicago and points in between as a traveling musician. Wanting to return to the East Coast to live with his wife and children, Shea took a gig with the Milt Trenier group for a summer engagement at Dunfey's in Hyannis. During that gig, he met Lou Colombo, who often sat in with Trenier's band, which specialized in a jazz-R&B mix. When Colombo offered Shea the drum spot in his band, Shea became a Cape Codder.

"Lou was the most popular and most well-respected as a musician," Shea said of the trumpeter he worked with for a dozen years. But it wasn't only work with Colombo that kept him busy. Shea soon became the first-call drummer on the Cape and performed with such jazz luminaries as Bob Wilber, Joe Muranyi, Marie Marcus, Dave McKenna, Lee Childs, Bobby Hackett and others.

His secret? "Make everyone feel comfortable," Shea said, whether playing his beloved bebop, traditional jazz, swing or anything in between. Shea also said he tried to keep an open mind. "I was never a 'drummer's drummer.' I didn't listen to the other drummers as much as I did to the piano players and the sax players. They would always say drummers weren't real musicians. I changed all that."

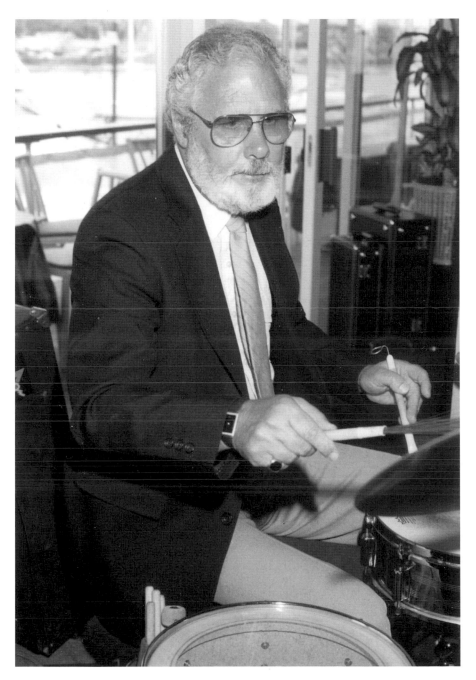

Drummer Frank Shea became the first-call drummer on Cape Cod in the 1980s, performing in a variety of bands. *Frank Shea collection.*

Shea was a musical nomad for much of his early career, as he made a place for himself in the hectic Los Angeles music scene before coming to Cape Cod. Regular gigs in Las Vegas and New York dot his extensive resume. But it was Cape Cod that seemed to fit Shea best.

In 1987, when he decided to move back to Connecticut, his many Cape Cod friends threw a big going-away party for him, featuring many of the musicians with whom he had played over the previous fifteen years.

It was a good break for Cape Cod music fans that Shea eventually came back to Cape Cod, settling in Orleans. In retirement, he is still a keen observer of the Cape's jazz scene. And he is philosophical about the decision, made by many, to come to live on the sandy spit of land.

"It takes a certain kind of person to come to live here. There was no work year-round." But with the kind of talent Frank Shea brought to a drum set, he managed to work more than most.

Bruce Abbott

A saxophonist of uncommon virtuosity, Bruce Abbott is among the most popular figures on the Cape's jazz scene. He works often in conjunction with guitarist Fred Fried, creating intricate, always swinging music.

A native of Pawtucket, Rhode Island, Abbott came to Cape Cod to live in 1981 and was immediately drawn to the Sunday jam sessions at the Barley Neck Inn in Orleans. He also became an occasional member of Lou Colombo's band at Tingles, a popular nightclub in Hyannis. For much of the '80s, Abbott split his time between the Cape and Rhode Island, where he taught music, and in 1989, he took a teaching job at Nauset Regional High School on the Lower Cape. Once Cape Cod was his permanent base, Abbott quickly became a prominent figure.

Abbott's musical range includes stints with the Judy Wallace band, an outfit that did everything from blues to R&B to jazz; the Artie Shaw Orchestra under the direction of another Cape favorite, Dick Johnson; and recently as a member of the Cape Cod Jazz Quintet with drummer Bart Weisman.

One non-jazz job Abbott had was as director of the Brewster Town Band, which plays traditional concert band music often on a bandstand in a park. Relying on his jazz contacts, however, Abbott once enlisted iconic jazzman Dick Wetmore to play cornet in the band. Abbott relates that on one occasion he was conducting the band and looked up to realize that

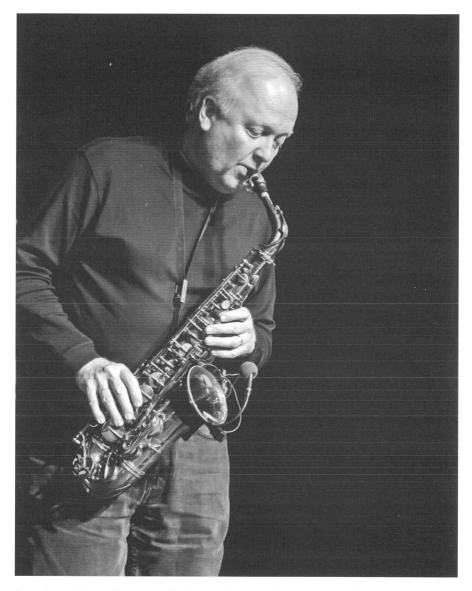

Saxophonist Bruce Abbott is a gifted improviser who plays a variety of jazz styles. *Bruce Abbott collection.*

Wetmore wasn't reading the music at all but creating his own musical line on a John Philip Sousa march.

"He was jamming with Sousa," Abbott recalls.

Rod McCaulley

Rod McCaulley is known not only as a versatile musician but also as a teacher who has guided many young Cape Codders into jazz. McCaulley, like many others, chose to make Cape Cod his home after vacationing on the Cape with his family, and in the years since he made the move, he has become a fixture on the Cape's jazz scene.

McCaulley came along at a time when there was a shortage of jazz bass players on the Cape and quickly found himself working in a variety of settings, in bands fronted by Lou Colombo, Dick Johnson and Marie Marcus, among others.

One of McCaulley's memorable gigs in the 1990s was at the East End Grille in Hyannis, where pianist Joe Delaney led a jazz group. McCaulley recalled that there was a competition going on between that club and the Roadhouse, not far away in Hyannis, where Lou Colombo and his son David were the proprietors. The Roadhouse also began offering jazz on Monday

Rod McCaulley is a talented jazz and classical bassist and a teacher of music who has mentored many younger players on Cape Cod. *Author's collection.*

nights in direct competition to the East End Grille, sometimes sending spies into the place to check out the competition.

Eventually, Colombo's place won out, and the Roadhouse has survived as a popular spot for jazz.

McCaulley said that while there might have been hard feelings, "time heals all wounds," and he ended up working with Colombo at the Roadhouse on Christmas Eve just a few months before Colombo died in a car accident in Florida in March 2012. He watched Colombo do his crowd-pleasing routine that night and thought, "He's the last of his generation."

McCaulley attributes the decline in the number of places for jazz musicians to play on Cape Cod to the passing of the generation that was raised on jazz, and he has branched out in order to keep his career in music alive. For several years, he led the youth jazz ensemble sponsored by the Cape Cod Jazz Society. Today, McCaulley works on a regular basis with the New Bedford Symphony and maintains a hectic teaching schedule.

"I get as much of a reward out of teaching as I do from playing," McCaulley said. "It's so good to see a lot of kids I've taught out there playing professionally."

Tyler Newcomb

Trumpet player and bandleader Tyler Newcomb has been a mainstay on the Cape Cod music scene since his days with the legendary show band the Gringos in the 1970s. Raised in California and educated in Arizona, Newcomb joined the Gringos and toured the country, spending each summer on Cape Cod.

"Eventually, all the members of the band bought houses and stayed on Cape Cod," Newcomb recalled. Since he became a Cape Codder, he has played with various jazz and non-jazz groups, but Newcomb is best known as the leader of the Cape Cod Conservatory Jazz Ensemble, a big band that often performs for charitable organizations to help raise money. Newcomb keeps the big band stocked with a mixture of professionals and talented amateurs. Among the players in the band are saxophonist Berke McKelvey, who is best known as a teacher at the Berklee College of Music in Boston. In recent years, Matt Joseph, a trumpeter who graduated from Barnstable High School before moving on to the New England Conservatory, has performed with the Cape Cod Conservatory band. Joseph is now embarking on a career as a professional trumpet player.

Trumpet and flugelhorn player Tyler Newcomb came to Cape Cod as a member of the band the Gringos and has led the Cape Conservatory Jazz Ensemble for many years. *Photo by the author.*

Since 1988, when he was appointed the band's leader, Newcomb has developed a solid book of arrangements the band can call on. "When I first started, I was buying music out of my own pocket. Now we have three hundred charts," Newcomb said.

As for his own roots in jazz, he says his early influence was the great trumpet player Chet Baker, associated with the cool sound of West Coast jazz in the 1950s. It's no surprise, since Newcomb grew up in California. "Chet was the one I listened to," Newcomb said.

Chandler Travis

Chandler Travis describes his music as "alternative Dixieland," "omni pop" or maybe "gospel music for atheists." Whatever it's called, it swings like mad, gets people dancing and features high-quality musicians, many of whom have serious jazz chops.

Chandler Travis (*fourth from left*) leads his Philharmonic, which merges jazz with rock and other styles and always appears in outrageous costumes. *Author's collection.*

Travis leads bands of various sizes, but the most jazz-oriented of his groups is the Chandler Travis Philharmonic, varying in size, but usually eight pieces.

From the time he was a child, Travis listened to jazz; Duke Ellington is a particular influence, but he cites Ella Fitzgerald, Count Basie and Ray Charles among his favorites.

By his teens, he was performing in Boston in an acoustic folk duo with Steve Shook, and in the early 1970s, Travis found his way to Cape Cod, just as the music scene was exploding with all kinds of new sounds and combinations.

"There was some hope of making a living as a musician then. The window has closed on that at this point," he said.

Still, Travis has remained a popular figure on Cape Cod and beyond. His Philharmonic performs in pajamas and strange hats, the visual counterpart to the musical mix the band creates.

"I like to provide surprises," he said of his musical approach. "You try your hardest to create something that is difficult to describe and then someone always asks you to describe it."

Over the years, his band members have included cornet/violin player Dick Wetmore and saxophonist Berke McKelvey, and regulars include drummer Rikki Bates and bassist John Clark. "We've had some amazing

players. I'm always dazzled by the people who have played with me," Travis said. Critics agree.

"The Philharmonic is like no big band you've ever heard. There's R&B, jazz, some lopsided blues, and rock & roll. Best of all, this stuff is just hilarious!" wrote Mark Saleski in the publication *Something Else* of this unique band led by a supremely talented guitarist, singer and songwriter.

Part II

The Places

BOURNEHURST-ON-THE-CANAL

It had a short life, but for fourteen summers, Bournehurst-on-the-Canal in Buzzards Bay was the place to go to hear top-name jazz bands.

From its opening in 1920, Bournehurst became a regular stop on the tour itineraries of the bands of Duke Ellington, Paul Whiteman, Cab Calloway and many other early jazz stars.

Bournehurst was also home to other kinds of entertainment. In addition to its ballroom, it was used as a movie theater. Fashion shows were held there, and social clubs held their functions there. Local kids were even allowed to play basketball when the ballroom wasn't in use.

But it was as a venue for the emerging jazz bands that Bournehurst was at its most glamorous.

Talent appearing there included the Coon-Sanders Nighthawks, among the first jazz bands to reach the masses by way of the emerging commercial radio industry. The Coon-Sanders outfit, co-led by drummer Carlton Coon and pianist Joe Sanders, got its start in Kansas City in 1919 and gained a wide audience in the mid-1920s through network radio broadcasts. Moving on to Chicago, and later to New York, the band maintained its radio presence and backed that up with relentless touring.

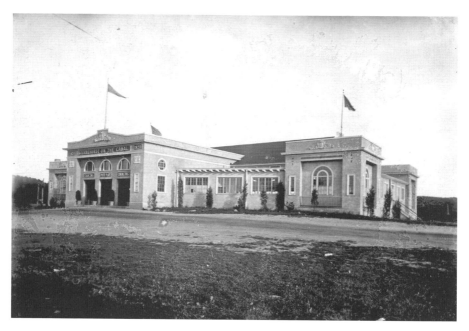

Bournehurst-on-the-Canal in Buzzards Bay was among the first places on Cape Cod to feature jazz. Dancers flocked there on summer evenings in the Jazz Age. *Bourne Historical Society.*

In *The Coon-Sanders Nighthawks: The Band That Made Radio Famous*, Fred Edmiston described one visit to Bournehurst in 1927 before the start of the summer season: "Staying at the Bournehurst in Buzzards Bay, Mass., the Nighthawks discovered that the summer resort had not yet opened. This provided the band with only a small crowd, but the Nighthawks found the area and the Pine Tree Inn interesting and beautiful."

Paul Whiteman earned the nickname "King of Jazz," although most music historians today don't think his music had much to do with jazz after Bix Beiderbecke left the band. However, in the 1920s and '30s, Whiteman ruled the music world and took his band to Bournehurst. Author Don Raymo records in *Paul Whiteman: Pioneer in American Music* that the Whiteman orchestra stopped at Bournehurst on May 31, 1930, "opening day of a short tour through New England."

Duke Ellington's band made the Bournehurst a regular stop on its many tours through the Northeast. Records show the Ellington band performed there in the summers of 1927, 1930 and 1932—and perhaps more often than that. Ellington, at that time, had already written some of his major jazz works and was breaking new ground with extended pieces as well as dance music.

Bournehurst-on-the-Canal featured a large dance floor and elevated bandstand. *Bourne Historical Society.*

It's likely the band's repertoire at that time included many of the songs that would remain in the band's book for generations and become American classics. Imagine the sounds of "Black and Tan Fantasy," "Creole Love Call" or "Mood Indigo" carried along on summer breezes beside the Cape Cod Canal.

Ellington was certainly a regular at Bournehurst, but the band he took into the popular Buzzards Bay nightspot had yet to reach its highest point. It would be a few more years before Ellington connected with his longtime musical partner Billy Strayhorn, who would help to propel Ellington's music into a more modern age.

Notes on file at the Bourne Archives indicate that Benny Goodman played at Bournehurst, but if he did, it is unlikely it was as the leader of his own band. Goodman's big band was not organized until 1934, a year after Bournehurst was gone. It is possible Goodman played at Bournehurst as a member of Ben Pollack's Orchestra, but no confirmation of that can be found.

Glen Gray's Casa Loma Orchestra performed regularly at Bournehurst. In the early 1930s, the Casa Loma was perhaps the most popular band in America. Gray's son Douglass would later settle in Plymouth, not far from Bournehurst.

In addition to nationally known jazz bands, Bournehurst also presented regional and local bands. A 1922 advertisement promotes an appearance by Ray Welch and his Shepherd's Colonial Orchestra from Providence, Rhode Island. A dollar admission got you into the band's Halloween party appearance.

Another advertisement promoted "Keith Pitman's Leviathans Recently with Paul Whiteman" on May 22, 1924. The ad went on to describe the little-known Pitman band as "the greatest of all dance bands," a claim many would dispute.

One bandleader with deep Cape Cod roots also brought his band into Bournehurst. Mal Hallett, who was descended from some of Cape Cod's first English settlers, led a swinging band beginning in the 1920s. By the early '30s, the band was at its peak, with sidemen such as trombonist Jack Teagarden and drummer Gene Krupa, among many others. It was this version of Hallett's band that played for dancers at Bournehurst.

Hallett's band played loud and swung like mad, which caused it to lose bookings at nightclubs. "On the other hand, ballrooms, better able to absorb the musical barrage, welcomed Hallett," wrote George T. Simon in his classic reference book *The Big Bands*.

The Hallett band, according to Simon, "worked consistently in every major New England ballroom and in many others throughout the country."

The name of this band on the Bournehurst stage has been lost to history. *Bourne Historical Society*.

Bournehurst-on-the-Canal was designed by Harry Lewis as a twin to Rhodes-on-the-Pawtucket, a very successful dance pavilion near Lewis's Rhode Island home. Walter L. Barrows built Bournehurst at an impressive cost of $100,000, according to contemporary accounts.

Surviving photographs of Bournehurst show a building that was classical in appearance, with two long portions separated by an inner courtyard. The dance hall's proximity to the Cape Cod Canal near the Bourne Bridge gave it an extra touch of romance for young couples out for an evening of dancing. Bournehurst was immediately part of the thriving New England dance hall scene, and traveling bands soon added the Bournehurst to their itineraries, along with Boston-area dance halls such as the Totem Pole and Nutting's on the Charles.

In a 1984 article published in the *Falmouth Enterprise*, Alice M. Gibbs wrote that Bourne residents who secured jobs at Bournehurst were "greatly envied." She mentioned Rosamund (Wing) Whittier, "who had the opportunity of selling tickets and meeting many of the greats." Her husband, Palmer Whittier, also worked at Bournehurst.

Although Bournehurst was a valuable part of the scene, it was not a part of the community for a long time. In January 1933, a fire caused a reported $10,000 in damage to the building. According to a story published in the *Cape Cod News*, a watchman on the nearby Bourne Bridge was the first to spot the fire, which had erupted in the building's basement. It was possibly started by teenagers who had sneaked into the building to smoke cigarettes. Fire companies from Buzzards Bay, Monument Beach and other villages responded and confined the blaze—but not before it heavily damaged the building. "The worst damage was done to the basement timbers where the fire burned through the first floor and to the dance hall along the canal side of the building," the newspaper account said.

At the time of the fire, Bournehurst was owned by Charles and Cy Shribman, Boston-based theatrical agents known for helping to launch the Glenn Miller Orchestra—perhaps the leading light of the big-band era—and many other top bands. Cy Shribman came to Bourne to examine the damaged building and told reporters he would rebuild.

Shribman knew that Bournehurst was a popular summer destination for thousands of dancers, and he often booked the Hallett band, which he managed, there. Shribman followed through and rebuilt Bournehurst, and it reopened for the 1933 summer season, but it was to be the final summer for the pavilion. In October 1933, another fire, far more serious, broke out, and Bournehurst was gone.

With its demise after just fourteen seasons, Bournehurst missed the height of the swing era, when the big bands of Benny Goodman, Artie Shaw, Glenn Miller, Count Basie, Chick Webb and so many more dominated American music and performed to thousands of dancers nightly.

In the summer of 1935, with the Bournehurst gone, the Ellington band played at Memorial Hall in Plymouth, Massachusetts, a few miles up the road from Bournehurst. While there is nothing remaining to mark the site of Bournehurst, the place inspired at least one songwriter. An undated piece of sheet music for a foxtrot by Mattie Pippin called "Bournehurst" resides in the Nina Heald Webber Cape Cod Canal Collection of Historic New England. On the cover is a simple illustration of Bournehurst-on-the-Canal from long-ago Cape Cod.

THE COLUMNS

Some people will tell you there are ghosts at The Columns in West Dennis. For years, The Columns has stood empty, with a for sale sign in front of the once-bustling nightclub and restaurant on busy Route 28. But there was a time when The Columns was a place where some of Cape Cod's, and the world's, best jazz musicians performed. If there are ghosts at The Columns, they are of the musical kind; they make swinging music by the sea on warm summer nights.

The building that housed The Columns was built around 1860 as a sea captain's home. Local workmen made it grand but still in keeping with Cape Cod style, which dictated against too much ostentation. It was constructed of southern yellow pine with the post-and-beam technique. The massive columns out front are the primary sign that this house belonged to someone important.

Around 1960, The Columns became a restaurant for the first time after having been a private home for its first century. In the early 1970s, it became a center for jazz when Warren and Beryl Maddows bought it. Warren Maddows operated The Columns as a place where he could present the jazz musicians he loved in a comfortable, affordable setting. Under Maddows's stewardship in the 1970s, great players, including pianist Teddy Wilson, vibraphonist Red Norvo and trumpet player Clark Terry, played at The Columns.

Tom Reney, in a blog on the *Jazz Times* website, recalled visiting The Columns in 1971 and hearing a band comprising Dave McKenna, Lou

Opening night at The Columns in 1979 was an occasion for tuxedos. *Ron Ormsby collection.*

Colombo and saxophonist Dick Johnson. Reney described that evening as "one of the watershed experiences in my early appreciation of jazz."

In his book *American Musicians*, Whitney Balliett described Maddows as a "gentle, self-effacing man whose great delight was to join McKenna near closing time for a couple of Tony Bennett–inspired songs." Balliett wrote that McKenna at first played "on a bandstand in the small bar to left of the front door. It was cluttered and noisy and cheerful and musicians like Bobby Hackett and Dick Johnson frequently sat in." Balliett reported that singer Teddi King worked for a month with McKenna at The Columns in the summer of 1971, and for a time, Teddy Wilson and McKenna, two of the top jazz players in the world, shared the stage at The Columns.

When McKenna took gigs off-Cape, Maddows presented talent that included Wilson, Norvo, Joe Venuti, Earl Hines and Zoot Sims. It was a low-pressure, high-quality gig for these jazz stars and a treat for Cape Cod jazz fans and the many who flock to the Cape in the summertime.

Maddows expanded The Columns to include a patio under a large tent at the rear of the building, increasing seating capacity and its appeal for jazz lovers. Maddows even defied the prevailing logic and kept The Columns open in the winter, with jazz talent always on hand.

But for all the great jazz presented at The Columns, Maddows never made much of a profit there. He paid the top talent he hired accordingly, and that contributed to his lack of financial success. Maddows died in 1978 at age fifty-one, and his widow kept The Columns running on a limited basis—but without jazz as the attraction.

It was in the spring of 1979 that The Columns was revitalized by new ownership, including Ron Ormsby, a jazz bassist trying his hand at restaurant/nightclub management, and pianist Mike Garvan.

Ormsby, who grew up in the Boston suburbs, had first come to Cape Cod for a gig at the Christopher Ryder House in Chatham in the summer of 1967 and continued to work often on the Cape. He said in a 2016 interview that he would drive by The Columns and note the top jazz names on the marquee out front during the time of Maddows's ownership. "Little did I know then that two or three years later I would be negotiating to buy the place," Ormsby said.

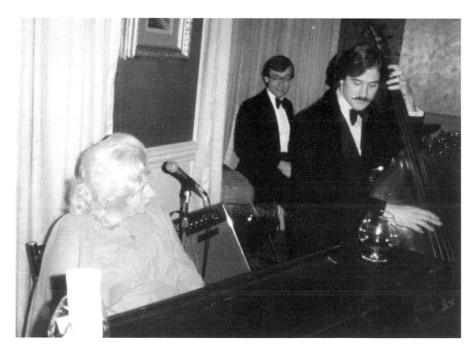

Marie Marcus, piano; Ron Ormsby, bass; and Dave Bragdon, drums, perform at The Columns on a New Year's Eve in the early 1980s. *Ron Ormsby collection.*

"I brought Ron into it," Garvan recalled. "I had heard that Warren Maddows had passed on, and I wondered what they were going to do with the place." After some negotiations, Ormsby and Garvan (with chef Doug Trott) took ownership of The Columns in early May 1979. Three weeks later, they opened the doors with their own Boston Jazz Quartet as the attraction: Garvan on piano, Ormsby on bass, Saul Shockett on saxophone and Marc Parmet on drums.

Day-to-day operations were Ormsby's responsibility, and he kept the jazz policy in place. The Columns remained popular, with a reputation as a first-class place to hear music. Garvan said he tired of the management side of running The Columns and wanted to "be more involved in music," so in 1982, he sold his interest to Ormsby. A year later, Trott left, and Ormsby continued to operate The Columns until 1985, when he sold it.

Ormsby said he gained a new perspective on the business of jazz from his time as the owner of a venue. "Since then I understand the financial hardships of having that kind of operation," he said. But he also said he learned that "if the music is causing a place to be successful the owners should compensate the musicians appropriately."

Ormsby said The Columns was a successful business, and his decision to close it was based on his perception that the time was passing for jazz clubs. He said that unlike many similar operations, The Columns did not leave a string of debts behind, and it was simply time for him to move on to other things. Ormsby ran a recording studio for many years and continues to work on Cape Cod and elsewhere as an in-demand bassist.

From time to time, someone takes an interest in the property, and jazz fans get their hopes up that they will once again have a comfortable jazz venue on Cape Cod. But for most of the time since it closed, The Columns has been vacant, with only the distant echoes of jazz to be heard there.

THE ATLANTIC HOUSE

Provincetown's Atlantic House remains, to many, a place where jazz of the highest order was heard regularly in the 1950s and '60s.

Under the ownership of the legendary Provincetown native Reggie Cabral, the Atlantic House presented musicians Gerry Mulligan, Zoot Sims, Billie Holiday and many others just off Provincetown's busy Commercial Street.

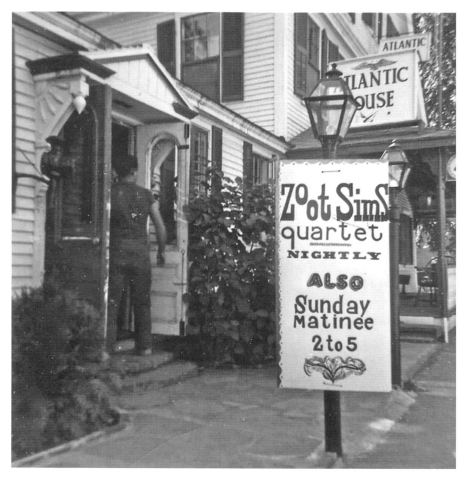

The Atlantic House in Provincetown was a popular spot for jazz in the 1950s and '60s. *Photo by John Reynolds.*

In a 1976 article in the *Cape Cod Times*, writer Mary Klein quoted Reggie Cabral, who recalled Billie Holiday performing at the Atlantic House on two occasions: "I remember vividly the last time Billie came down the alley in a huge, black chauffeur-driven limousine which belonged to the Associated Artist Productions (Holiday's booking agents). She came heavily guarded. She was surrounded by people. She was heavy merchandise." Cabral went on to describe Holiday arriving carrying evening gowns but with "her shoes and her makeup, her personal things in a paper bag." Holiday at that time was barred from working in New York nightclubs because of previous run-ins with the law. "The first thing she wanted was a bottle of

gin. When she said she wanted a bottle of gin, she wanted a bottle of gin," Cabral recalled. Holiday also demanded a pork chop sandwich before going on stage.

"We finally got her on stage and what was unbelievable was her drawing capacity. She outdrew anybody who ever played the Atlantic House and we paid her the least of what we paid anyone of any known status." Cabral said he was "kind of delighted when her engagement was over because in the end I realized I couldn't take it." He recalled Holiday as having "a nice disposition" but believed "she'd been terribly hurt. I think she felt alone. She was terribly unsure of herself until she sang."

Holiday died in July 1959 at age forty-four of the effects of alcohol and drug abuse. At the time of her death, she was technically under arrest for possession of narcotics. While the exact date of Holiday's final appearance in Provincetown, possibly the last of her career, is lost to history, it's probable it was in the summer of 1958.

The Atlantic House was also where the "White Billie Holiday" performed. Stella Brooks, a now-forgotten jazz singer, was recalled by Reggie Cabral as "a very irrational person but a marvelous performer, who would not sing unless she believed she had the audience's undivided attention." Brooks was a close friend of many in the New York literary world, including Truman Capote, Norman Mailer (who would become a longtime Provincetown resident) and Tennessee Williams. Cabral recalled Williams listening to Brooks sing one night while jotting down some lyrics. The next night, Brooks sang those lyrics at the conclusion of her show.

"She played the Atlantic House for a long time. She played one whole season there," Cabral recalled. "She was funky. She was marvelous."

Cabral also told of presenting baritone saxophonist Gerry Mulligan at the Atlantic House. "He was sensational. He got so inspired by the audience and they were so receptive, that he would go out into the audience and play. He'd step on the chair and he'd finish on the table and he'd really blow his heart out," was Cabral's description of Mulligan's appearances at the Atlantic House. This account stands in contrast to the usual description of Mulligan, who, as a leader of the "cool school" of jazz in the 1950s, usually took a more studied and calm approach to his playing. But Mulligan also had a reputation as an intense player, and it's not out of the question that an audience could move him to such a display.

Canadian writer John Reynolds captured Mulligan and tenor saxophonist Zoot Sims on stage at the Atlantic House in the summer of 1960 while visiting Cape Cod from Toronto with a friend. "The Atlantic was rustic inside—I seem

Gerry Mulligan (*left*) and Stan Getz, two leading jazz stars of the day, perform at the Atlantic House in the summer of 1960. *Photo by John Reynolds.*

to recall bare walls and roof beams—but this was typical of seaside clubs at the time. We went past the place in the evening but I believe it was too crowded for us to enter—the afternoon jam session with Mulligan was a happy anomaly." It was at that jam session that Reynolds took some photographs that capture the era perfectly. "The photos are still wonderful to me, but oh how I wish I had had the portable digital recorder I have today and the permission of Mulligan et al to capture the music—in devotion to swing, the uninhibited fun (Mulligan kept repeating 'Nice! Nice!' after everyone's solo) and the joy of an early summer afternoon by the sea."

Reynolds also recalled the Provincetown scene of the day:

> *Provincetown was very different in 1960. While it may well have been popular among the gay community, the fact was not openly recognized—nor, of course, was the gay community generally. Still, it had a large artistic constituent and was something of a backwater for tourists. It was also very conservative. My friend Dave and I met two attractive young women there from Montreal, one of whom we quickly ascertained, knew a mutual friend of ours. We settled down for dinner and drinks at (I believe) an outdoor cafe. Dave wanted to record the event on his own camera, which he left at the tourist home where we were staying. Jogging back to the cafe he was stopped by two cops in a police cruiser who demanded to know what he was doing, running through town.*

*They demanded identification and while they rummaged through Dave's wallet
told him, "We don't want troublemakers around here." Dave was unsure why
jogging down a road was making trouble, but he was too cautious to ask, and
promised the cops that he would walk everywhere from that point on.*

In Cabral's memory, as related by Mary Klein in the 1976 newspaper article, Mulligan also appeared at the Atlantic House later, perhaps in the early 1960s, and was accompanied by his then-girlfriend, Broadway and film actress Judy Holliday. Cabral related that Holliday was already feeling the effects of the cancer that would take her life in 1965 and she and Mulligan just wanted to enjoy privacy by the ocean when Mulligan was not performing at the Atlantic House.

Beata Cook, in a column published in 2015 in the *Provincetown Banner*, remembered the Atlantic House presenting singers Ella Fitzgerald, perhaps the greatest jazz singer of all, and Eartha Kitt, who, while not known as a jazz singer, appealed somewhat to a jazz crowd.

"There was no cover charge," Cook wrote, "only a two-drink minimum to enjoy these stars." She noted sadly that Cabral didn't make a go of it financially presenting jazz in those days.

The Atlantic House continues to operate as perhaps the East Coast's best-known gay bar and is considered a cornerstone of the Provincetown entertainment community.

STORYVILLE CAPE COD

For a brief time, Cape Cod was home to a nightclub that was the rival of those in the big cities in terms of the jazz talent performing there.

Storyville Cape Cod, located in the woods of Harwich and operated by one of America's top jazz impresarios, presented most of the top jazz artists of the 1950s and also hosted comedians and folk music artists, who were then enjoying a boom time.

George Wein, the driving force behind the Newport Jazz Festival, and his friend Paul Nossiter, a clarinet player who had performed in Wein's Mahogany Hall club in Boston, were partners in the Storyville Cape Cod operation. Nossiter and his family traveled to Wellfleet on the Cape each summer, and Wein and his wife became enamored of the place while visiting them.

"Meandering around the Cape, I had come to the decision that it would make an ideal spot for a summer Storyville," Wein wrote in his 2003 book

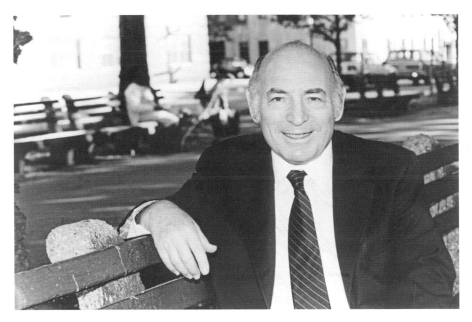

George Wein, the force behind the Newport Jazz Festival and other music festivals around the world, operated Storyville Cape Cod for four summers. *Author's collection.*

Myself Among Others. Storyville in Boston closed each summer, so the Cape Cod operation dovetailed nicely into his business plan.

Wein and Nossiter found just the right spot in the former Robin Hood Inn. The Robin Hood dated back to Prohibition days, and stories were told about famous faces being spotted there. One newspaper account of the 1950s referred to the Robin Hood as "a castle-like mansion off Route 124." But when Nossiter and Wein went to work there, the place had more recently been a turkey farm. Storyville Cape Cod opened for the summer of 1957 serving drinks and jazz.

Opening week featured the biggest jazz star of them all, Louis Armstrong. It was a booking few promoters could have pulled off, but with Wein's personal connections in the business and his reputation as a presenter of jazz, it came to be.

Storyville Cape Cod also did big business presenting one of the biggest jazz stars of the day, George Shearing. In the 1950s, it was still possible for a jazz artist to have a hit record on the charts, and Shearing was selling a lot of records, with hits such as "Lullaby of Birdland," his composition, which became a jazz standard. In the 1950s, Shearing albums, including *Black Satin*, *White Satin*, *Burnished Brass* and others, routinely made the pop

MENU

until 8:15 price of entree includes choice of appetizer (shrimp cocktail extra), salad, dessert and beverage. After 8:15 all prices a la carte.

TWO BROILED KIDNEY LAMB CHOPS 4.50
"To me, chops is the most important thing." LOUIS ARMSTRONG
"There are some classics the public will always eat up."
 GEORGE SHEARING

TWO 1 LB. BROILED LIVE CHATHAM LOBSTERS 5.25
"I see no reason why some things can't be cool one minute, then red hot the next. . . . " GERRY MULLIGAN

1 LB. BROILED LIVE CHATHAM LOBSTER 3.95
"We have accepted the challenge of working in a smaller framework, while still maintaining the larger concept."
 THE MODERN JAZZ QUARTET

FRIDAY FISH SPECIAL (to be announced)
"This is the one where we elaborate on whatever anyone brings up, and even we don't know how it will end — or how it will begin, from week to week. To me, this is a really honest kind of improvisation."
 DAVE BRUBECK

BARBECUED SPARE RIB PLATTER with Candied Yams
 3.85
"You want to know what's impossible? Trying to describe Kansas City to somebody who wasn't ever there." JO JONES
c.f. Ben Pollack and his Pick-A-Rib Boys, Delaunay, *New Hot Discography*, p. 197.

VEGETABLES (to order)

"Regardless of how many changes take place, there are certain elements in jazz which must be present, or it just isn't jazz anymore."
 JOHN HAMMOND

Desserts

Ice Cream .60 Sherbet .55 Sundaes .85 Home-Baked Pastries —
"Jelly Roll Jelly Roll is hard to find, You always get the other kind. . . ."
 BESSIE SMITH

SANDWICHES

"What started out as a simple jam session is now one of the finest clubs in the world." GEORGE FRAZIER (in a tribute to Storyville)
Ham 1.25 Ham and Egg 1.25 Hamburger 1.25 Cheeseburger 1.50
Bacon and Egg 1.25 Sliced Chicken 2.00 Storyville Club 2.25

JAZZ for early risers

Breakfast — 12:00 to 1:00 a.m.
Ham, Bacon, or Sausage, with two eggs, any style, coffee 1.50
"The point is, that those who don't like eggs can just drink."
 MRS. L. L. LORILLARD

Beverages (choice of one on dinner)

Coffee .60 Tea .60 Iced Coffee .75 Iced Tea .75
Milk (bottle) .60 Ginger Ale .90 Coca Cola .90

A page from the Storyville menu. Quotes from jazz musicians were used to describe the entrées. *Author's collection.*

89

charts—giving jazz a crossover appeal—so that even people with only a passing interest in jazz would be attracted.

Storyville Cape Cod was never successful as a restaurant. Wein and Nossiter had no experience as restaurateurs. But for the limited time it did offer food, its menu was a work of art, and copies of that menu are still collectors' items. Each entrée was linked to a jazz artist. For example, the broiled Chatham lobsters entrée ($5.25) was accompanied by a quote from Gerry Mulligan: "I see no reason why some things can't be cool one minute, then red hot the next." And there was the ground sirloin steak plate ($3.50) with a quote from Stan Kenton: "What we have done is taken old, familiar elements and put them together in a totally new way. All it takes is genius."

The music was presented in what Nossiter described as "just a big, oblong room. We enlarged it so it could hold 600 people." Reporter Ruth Young, writing in the *Cape Codder* newspaper in July 1958, described the scene: "Around and about Storyville Cape Cod, the small craft warnings are flown every night 'cause they're blowing up a storm inside." Young wrote that the atmosphere was casual with "lots of applause and an exchange of smiles and small talk between musicians and listeners."

The Duke Ellington Orchestra, Ella Fitzgerald, Louis Armstrong, Pee Wee Russell, Buck Clayton, Dave Brubeck and many other top jazz stars of the 1950s and early 1960s were routinely booked and enjoyed the resort-like atmosphere and relaxed tempo of summer life on Cape Cod. Top comedians, including Phyllis Diller and Shelly Berman, were also booked at Storyville Cape Cod, sometimes in conjunction with jazz artists and sometimes on their own.

The national press even took note of what Wein and Nossiter were doing in Harwich. "Storyville Boston opened this week as Storyville Cape Cod for its summer season," *Billboard* magazine noted in late June 1959. The article went on to note that clarinetist Pee Wee Russell (whose appearances on Cape Cod dated back to the 1920s), singer Jimmy Rushing, trumpeter Buck Clayton and trombonist Vic Dickensen were among the musicians taking part in a "Dixieland jamboree."

Nossiter said in 2016 that much of the day-to-day operation of Storyville Cape Cod fell to him because Wein was occupied with his Newport Jazz Festival in the summertime. He recalled driving Duke Ellington back to Ellington's motel after a performance late one night and having Ellington prepare breakfast for him in the motel room's kitchen.

Nossiter also said in a 1999 interview that when pianist Erroll Garner played at Storyville Cape Cod, he made it a point to listen every night of the engagement. "The most creative musician I've ever seen was

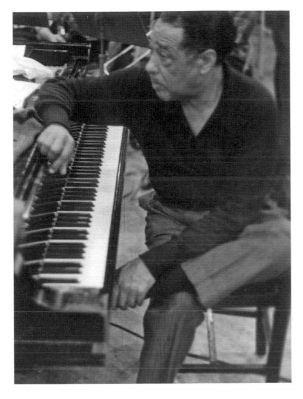

Duke Ellington at Storyville. He was among the many top names who performed there. *Photo by Jack Bradley.*

Erroll Garner. Night after night he would sit at that piano and pour out improvisations."

In the summer of 1959, the Cape's jazz historian and photographer, Jack Bradley, captured the visit of the Ellington band on film. His photographs show Ellington's musicians enjoying the local beaches, playing tennis and generally behaving like tourists.

A newspaper ad from 1960 listed the summer lineup at Storyville as including Ruby Braff (who would years later become a Cape Cod resident), Sarah Vaughan, Benny Goodman and Gene Krupa.

In a 1999 interview, Wein said the Cape Cod operation was never a big financial success. "The first year we lost a lot of money. The second year we lost a little money. The third year we broke even," he said. By the fourth summer, Storyville Cape Cod was also taking advantage of the folk music revival that was sweeping the nation and booked artists such as Odetta and Pete Seeger. "The fourth year we were set to make it, but that was the year the Kingston Trio broke up, and they were to be the centerpiece of the year. We had to close for 10 days [when the Kingston Trio canceled]. That did it. We couldn't sustain ourselves anymore."

The great alto saxophonist Johnny Hodges takes a break at a Harwich beach during a visit by the Duke Ellington Orchestra. *Photo by Jack Bradley.*

Today, a housing development stands where Storyville Cape Cod once was.

Nossiter and Wein shared a commitment to civil rights issues as well as to music, and in its own way, Storyville Cape Cod contributed to the cause by presenting black and white artists and welcoming racially mixed audiences. In 1999, Wein speculated that the slight resistance he encountered from some Harwich officials was because Storyville would attract racially mixed crowds, which was somewhat unusual for Cape Cod in the 1950s. He acknowledged that finding lodgings for black artists was at times difficult, so racial issues were certainly present.

"Maybe that was part of it, but I think it was just the general conservatism, a reaction to bringing a club like that to old Harwich. We had problems at the start, but the neighbors spoke up for us," Wein said. Cal Kolbe, a writer and editor who was Nossiter's wife at the time of Storyville Cape Cod, said in a 1999 interview that Storyville was "utterly unique and singular," and it featured a sound system that was tailored to the needs of musicians, which made for a better experience for the listeners as well.

Partly because of his involvement at Storyville, Paul Nossiter became a full-time Cape Codder, working as a teacher and continuing to perform in

various jazz groups well into his eighties. In the summer of 2016, he was still performing on a regular basis.

Storyville has receded into Cape Cod history, but it is not forgotten. In 2011, the Harwich Cultural Council organized a reunion concert to celebrate the jazz legacy Storyville left in the town. Featured were many of Cape Cod's jazz players: Lou Colombo, Bart Weisman, Fred Boyle and, of course, Paul Nossiter.

Was Storyville Cape Cod too good to be true? Possibly. Even in the 1950s, the economics of hiring top jazz artists to perform in the woods of Cape Cod, with all the travel expenses, was not something that could be sustained, even by someone like George Wein, who knew everyone in the jazz world.

"I had put together a schedule every bit as impressive as the one in Boston: Erroll Garner, Benny Goodman, Louis Armstrong, Duke Ellington, Sarah Vaughan, Ella Fitzgerald. But even with these stars, it was difficult to show a profit. We couldn't charge enough money and the expense of running a ten-week operation was too much," Wein wrote.

Wein, whose Newport Jazz Festival has given birth to many other music festivals around the world, was philosophical about Storyville Cape Cod in a 1999 interview: "We had wonderful times there, but you've gotta keep moving."

THE PLACES THEY PLAYED

Cape Cod has been home to countless venues that presented jazz as the main form of entertainment—some for a season, some for a decade or more. In many cases, they represented someone's dream of a place where great music could be offered to people who would pay for the privilege of hearing it. Too often, however, those dreams were short-lived.

As with nightclubs, restaurants and music venues anywhere, it's a tough business, and in a seasonal economy such as Cape Cod's, it can be downright brutal. But the list of venues for jazz is long and fondly remembered. In an article published in the *Cape Cod Times* in the 1980s, Don Walsh recalled some of the more obscure places where jazz once dominated. His list included the Sagamore Inn in Sandwich, where pianist Walter Johnson—"a sepia-toned keyboard masseur," in Walsh's words—was the featured attraction.

On Martha's Vineyard, a few miles off Cape Cod's coast, the Tivoli Ballroom was a summertime jazz spot in the 1920s. Frank Foster, a popular bandleader around New England around the time of World War I, played

The Tivoli Ballroom in Oak Bluffs on Martha's Vineyard featured jazz as well as boxing matches and movies. *Frank Foster III collection.*

often at the Tivoli. Foster played clarinet and saxophone in the band of his father-in-law, Will Hardy, who was the proprietor of the Tivoli.

"My dad's band spent more time on Martha's Vineyard than anywhere else," recalled Foster's son, Frank Foster III. "The Tivoli was a real hot spot for dancing. People used to go over to Martha's Vineyard just for that purpose." His father went on to have his own very popular band, and in the late 1920s, he was named the most popular musician in New England by the *Boston Herald Traveler*.

The Tivoli thrived as an entertainment center just as jazz became part of the American scene. Newly mobile tourists with money to spend took the ferry to Martha's Vineyard for a day, a weekend or a longer vacation.

Like its counterpart Bournehurst-on-the-Canal in Buzzards Bay, the Tivoli also hosted events other than dancing; boxing matches and movies were popular attractions there as well. But it was as a dance hall that it made its name.

The Tivoli was torn down in 1964 to make way for what was then the new Oak Bluffs Town Hall, but the place is fondly remembered each September with a daylong festival. It's held shortly after Labor Day, when the summer crowds have diminished. Circuit Avenue is closed to traffic for "a day of gleeful recognition by folks too busy to have seen each other all season long," wrote Skip Finley in the *Vineyard Gazette* in 2013.

The elder Frank Foster gave up his band when he married and began to raise a family, but he never lost his love of jazz. After a career as an artist and designer, he retired to Cape Cod and, with Jack Bradley, founded the Cape Cod Jazz Society in 1977. That organization was responsible for helping to keep jazz alive on Cape Cod for twenty-five years.

Other sites mentioned by Walsh include the Hyannis Coffee House, the Casino in Falmouth Heights, the Casa Madrid in Bass River, the Blue Moon Ballroom in Buzzards Bay, the Megansett Tea Room in North Falmouth (see the section on Bobby Hackett) and the Yachtsman on the waterfront in Hyannis.

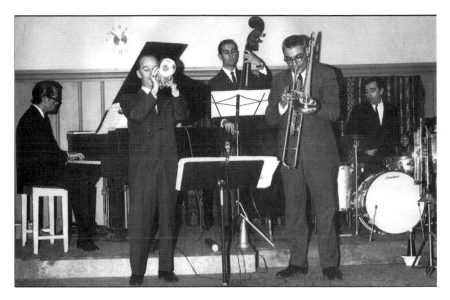

Trumpet player Bobby Hackett leads a band at the Rooster in West Yarmouth in 1964. With him are Roger Kellaway, piano; Dave Sibley, bass; Nick Stabulis, drums; and Marshall Brown, valve trombone. *Author's collection.*

There was also The Rooster along Route 28 in West Yarmouth, which later became Johnny Yee's, where a classic LP was recorded by Dave McKenna, Dick Johnson and Lou Colombo.

Len Healey's Velvet Hammer at the East End of Hyannis featured jazz for several years, mixed in with other musical entertainment.

There was the mysterious Red Door in Hyannis, which advertised "live jazz" for a while in the 1970s, although few, if any, can remember where it was located.

The East End Grille in Hyannis had success with jazz under the ownership of Henry DiPrete in the 1980s. A house band led by pianist Joe Delaney and trumpet player Lou Colombo was a popular attraction, with jam sessions drawing good crowds.

The Captain Linnell House in Orleans had its jazz moments, presenting virtually every important Cape Cod jazz player during its long history.

The Reading Room at the Asa Bearse House on Main Street in Hyannis gained a reputation as a jazz venue when Don McKeag ran it. In a 1984 article, the *Register* newspaper described the "stylishly dressed young professionals" who turned out to hear Dave McKenna there.

McKenna was a favorite not only of the fans who flocked to hear him but also of the Reading Room's proprietor. In his 2015 memoir, McKeag said the place was "a dream come true" for him, a place where he could

present his favorite piano player in a comfortable setting. And McKenna was good for business. "Once he arrived, even our lunch business improved," McKeag wrote. "Other fine musicians and celebrities soon became regular customers."

McKeag said performers appearing at the nearby Cape Cod Melody Tent often turned up at his bar after their own shows. He recalled that Rosemary Clooney, Jack Jones, Dihann Carroll and jazz great Woody Herman "would rise from their table to sing or play a song or two with Dave."

But there was a downside. "With no cover and no minimum it was the best deal in town. A glass of wine was $1.95, a mixed drink was $2.50 and customers got to hear one of the world's great piano players. At those prices, no wonder I wasn't making any money."

The same article in the *Register* that drew attention to McKenna's appearances at the Reading Room went on to highlight what was then a thriving jazz scene along Main Street.

Down the street, pianist Mike Markaverich was holding forth at MD Armstrong's. "Markaverich's fingers glide across all 88 spots on the keyboard, with feeling fairly flowing onto the keys," the *Register* reported. The article went on to describe his ability to instantly play requests from the jazz-loving crowd. In that same piece, Markaverich (who later relocated to the Sarasota, Florida area and continued his career there) acknowledged that playing jazz in a restaurant that was sometimes full of tourists and casual listeners had its drawbacks. "You just have to play for yourself," he said.

And there was the nightclub in the West End of Hyannis that was immortalized by singer Larry Marsland in his play *Panama Club*, which was first produced in 2006 at Cape Cod Community College and revived in 2010 at the Barnstable Comedy Club.

Marsland uses the long-gone Panama Club (sometimes known as the Club Panama) as the setting for his play, which features the fictionalized story of Marsland's mother, Agnes, meeting and falling in love with his father, Larry, in 1941, only to have their romance temporarily interrupted by World War II.

During the war years, the Panama Club was owned by the Caggiano family, and Hugo Caggiano, twenty-three at the time the war broke out, worked there as a bartender. Caggiano told the *Cape Cod Times* in 2006 that the Panama Club managed to survive the war years. "Nothing changed. We were lucky," he said.

Amelia Findlay of Hyannis, who was a waitress at the Panama Club in the 1950s, told the *Times* of a night when undercover police officers arrested members of the band for drug possession in the middle of their set.

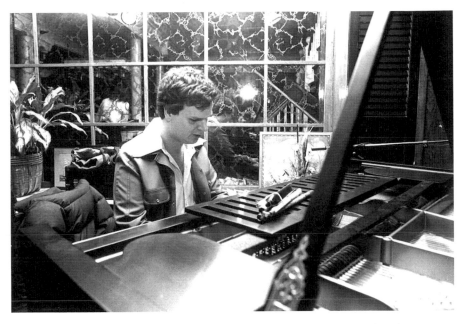

Pianist Mike Markaverich was a popular jazz player on Cape Cod before relocating to Florida. *Author's collection.*

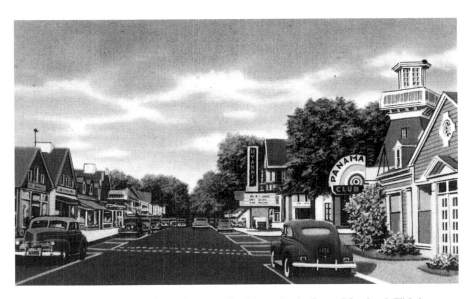

The Panama Club in Hyannis was immortalized in a play by Larry Marsland. This image shows the club's location on Main Street in Hyannis in the 1940s. *Author's collection.*

Marsland said his account of life at the Panama Club was fictionalized but based on stories passed down by his mother and aunt. "I heard they went there and flirted with the Coast Guard boys." He said Cape Cod during the 1940s was an isolated place for the locals, and the chance to hear live jazz and swing music was exciting. He also said the coming of World War II brought thousands of GIs to Camp Edwards on the Cape, and it was only natural that many of those soldiers found their way to the Panama Club during their off hours.

While Cape Cod, being in the North, did not suffer from the Jim Crow segregation laws found in the South, Cape Cod certainly had its own, more subtle manifestations of racism, but stories persist that the Panama Club was a place where black and white patrons mingled freely.

Jack Bradley, Cape Cod's eminent jazz historian who grew up not far from the Panama Club, remembers going there around 1950, even before he was old enough to go inside. "When I was in my late teens, I would stand outside and listen to the music," Bradley said. And he said the level of music was high. One band in particular he recalled hearing was that of trumpet player Howard McGhee, a star of the bebop school of the late 1940s and 1950s.

Bradley also recalled, however, that McGhee ran into trouble with the law during an engagement at the Panama Club. It was an incident Bradley said had racial overtones.

Some places have slipped into the land of the legendary. Old-timers will recall the Sandy Pond Club in West Yarmouth. It was a former hunting lodge with a huge fireplace and was located at the very end of Town Brook Road, a secluded place on West Sandy Pond. Jack Braginton-Smith and his wife bought the place from the chief of police in Yarmouth, Nelson Cressy, in 1953. Braginton-Smith ran the place until 1971. There was jazz at the Sandy Pond Club, for sure, but also rock and roll to keep audiences, sometimes as many as four hundred patrons, entertained.

A regular attraction was trumpet player Lou Colombo and his band, usually a quintet, according to a document at the Historical Society of Old Yarmouth, which went on to say, "As you came in the door, the bar was to the left. There was a big porch on the back facing the pond. Sometimes on Sunday afternoons some of the patrons and staff would put on a water skiing show for those on the porch to see."

There are also stories of patrons diving off the deck into the pond, with at least one broken leg reported. In a 1999 interview, Braginton-Smith recalled a tradition called the Lefty-Righty Club, in which customers had to hold their drinks in either the left or right hand, depending on whether a specified cup

hung from a hook on the left or right side of the room. "Throughout the night, the saxophone player would sound out a trademark tune signaling the mug was on the move, and everyone had to switch drinking hands," the *Cape Cod Times* reported. Violators would be assessed a twenty-five-cent fine, which went to help pay for a big end-of-season party.

Jack Bradley also remembered hearing great jazz at the Sandy Pond Club. In the late 1950s, according to Bradley, the place was "packed all the time" with locals and vacationers looking for a good time. Bradley remembers Leroy Parkins's Excalibur band performing at the Sandy Pond Club. At that time, Parkins incorporated a huge, and rare, bass saxophone into the band from time to time. During a break between sets, a bar patron poured a pitcher of beer into the saxophone's large bell, making the instrument unplayable. "When he went to play it, nothing came out," Bradley said. So Parkins—having seen the stunt before, no doubt—simply tipped the large instrument over and poured the beer out onto the floor before continuing to play with the band. The Sandy Pond Club was just that kind of place.

Sunday afternoons at the Sandy Pond Club were legendary. Jack Braginton-Smith provided this reminiscence to the Historical Society of Old Yarmouth in 2006:

> *Speaking of Sunday afternoon jam sessions—we had an entertainer called Dick Doherty who sang little ditties and played the piano, guitar, or whatever, and was much beloved by the South Boston Irish week-end warriors, of whom we had a more than adequate supply. Every week during the season I would spend a few minutes with him saying no matter what, do not play "Southie is My Home Town"...people would keep buying Dick drinks until he got a little mulled and then, as they knew he would, he would burst into "Southie." 300 people went wild; standing on chairs, tables, and on occasion hanging from the rafters, they joined in with the lyrics. By this time, I was safely ensconced down cellar counting beer cases by the hundreds. When the building began to vibrate, I knew the song was over and that the crowd was showing their appreciation. Usually this meant that he was through for the afternoon (and the night, too). We usually had three cops on duty to maintain order and check IDs and more often than not they would be found in the crowd standing on the tables at the finale.*

Just up the road from the Sandy Pond Club was the Mill Hill Pavilion on Route 28 in West Yarmouth. The pavilion—opened in 1917, according to the Historical Society of Old Yarmouth—included a 70- by 140-foot dance floor and "catered to a newly mobile automobile population."

The Mill Hill Pavilion specialized in jazz and dance bands that traveled the regional circuit, and top names were not booked there. Early attractions included Heywood's Jazz Band in 1918. Others to perform there had intriguing names reminiscent of the top bands of the day; there was Count Lou Bonick in 1926 and Duke Kamahua and the South Sea Seranaders, also in 1926. It's doubtful Count Basie or Duke Ellington had any real competition from these outfits.

Among the bands to play there was one led by Yarmouth's own Ernie Baker, who brought a six-piece outfit into the Pavilion. Baker was for a time also the manager of the Pavilion, which burned to the ground in 1928.

The Music Box in West Yarmouth, now just a memory, had a reputation for bringing top jazz talent to Cape Cod. In September 1960, *Down Beat* magazine reported that "Herb Pomeroy's new band played a week's engagement at the Music Box at West Yarmouth on Cape Cod." *Down Beat* went on to say that jazz singer Dakota Staton shared the bill with Pomeroy.

At that time, Pomeroy was becoming a popular teacher of jazz at the Berklee School of Music in Boston, but he also led a series of big bands featuring the best New England jazz players. Among the talent that passed through his band were trumpeters such as Lennie Johnson, Everett Longstreth and Joe Gordon and saxophonists Boots Mussulli and Jaki Byard (although Byard later became much better known as a jazz pianist). Ray Santisi was often on piano and John Neves on bass in Pomeroy's bands, so Cape Cod audiences must have had a great treat.

Staton, of course, had crossover hit records, including *The Late, Late Show* and others, and she was among the best-known singers in America at the time of that 1960 gig.

Johnny Yee's in West Yarmouth achieved a measure of immortality when Dick Johnson, Lou Colombo and Dave McKenna recorded a now-classic album there. But they were not the only top-flight jazz artists to grace Johnny Yee's stage. In February 1975, trumpeter Maynard Ferguson brought his big band to Johnny Yee's as part of one of the band's lengthy tours. In the 1970s, Ferguson was introducing elements of rock into the standard big band sound with some exciting results.

Earlier in its life, the building that housed Johnny Yee's was the home of The Rooster. Jazz was part of the scene at that time as well, with Bobby Hackett leading a band there from time to time.

Part III
Beyond Category

JACK BRADLEY

Photographer, record collector, historian and entrepreneur are all titles that could be attached to Jack Bradley's name. But most of all, to people on Cape Cod and around the world, he is known as one of the people who keeps jazz alive through a sincere commitment to the music and the people who play it.

Bradley played a bit of trumpet in his younger days, but it was his friendship with the greatest trumpet player of them all, Louis Armstrong, that is the centerpiece of his life in jazz.

Bradley grew up in Cotuit and was educated for a career at sea at Massachusetts Maritime Academy in Buzzards Bay. As a teenager, he was interested in photography and jazz, two things that would shape his life.

It was in 1954 that Bradley first saw Louis Armstrong perform in person in a concert at the now demolished Legion Hall on Barnstable Road in Hyannis and took his first photographs of Armstrong. For Armstrong, it was just another stop on an endless trail of concert appearances that took him to major cities and small towns across the United States and around the globe.

In a 2016 interview, Bradley remembered going back to see Armstrong two more times with his friend and fellow jazz fanatic Bob Hayden when Armstrong returned to Hyannis each year.

Jack Bradley is an authority on Louis Armstrong and a founder of the Cape Cod Jazz Society. Here, he visits the Louis Armstrong House Museum in New York. *Photo by James Demaria.*

By 1958, Bradley had moved to New York, and it was there he met the woman who would be his link to Armstrong. Jeann Failows was a columnist for *Coda* magazine. As Bradley tells it, one day Failows asked him who he considered the greatest jazz musician. When he answered that it was Louis Armstrong, Failows at first pretended to dismiss his choice as old-fashioned. But Failows was joking. The fact was that she worked for Armstrong, helping him answer his voluminous mail.

Bradley became coauthor of Failows's *Coda* column, and in 1959, on the day after Christmas, she introduced Bradley to Armstrong backstage after Armstrong's concert at Carnegie Hall. Bradley, of course, documented the moment in photographs, as he would thousands of times in the years to come.

While living in New York, Bradley worked as a merchant mariner. "I had a romantic idea about ships," he said. When time allowed, he photographed not only Armstrong but also many other jazz musicians then on the scene. And it was a particularly fertile time for jazz. Old-timers of Armstrong's generation like Duke Ellington and others were in the prime of their careers, even as younger players, such as Gerry Mulligan, Stan Getz, Dave Brubeck, Thelonious Monk and Dizzy Gillespie, brought new energy to the music. Bradley photographed all of them.

Bradley was involved with the founding of the New York Hot Jazz Society and its jazz museum on West Fifty-Fifth Street in New York, a short-lived venture that ultimately failed after several changes of management and lawsuits. He gave up going to sea and took a job as a cargo mate, working ashore for the Grace Line on New York's waterfront. That way he had more time to devote to jazz.

Bradley became a prolific columnist for *Coda*, the *Bulletin* of the Hot Club of France, *Jazz Journal* and other publications, and his photographs appeared in numerous magazines and books.

Bradley was never a paid member of Armstrong's staff, but he was a frequent guest of the trumpeter and a prime source of photographs when Armstrong's manager Joe Glaser needed new publicity material. In this way, Bradley's work was seen around the world.

Bradley often was invited on tour and spent countless hours at Armstrong's home in Corona, Queens, in New York, which is now the site of the Louis Armstrong House Museum.

Although Bradley was part of the New York jazz scene, working as road manager for the pianist Erroll Garner and manager for trumpeter Bobby Hackett, among other jobs, he decided to return home to Cape Cod in 1975 and settled with his wife, Nancy, in Harwich. There, he started a charter boat business he would run for many years and began a new chapter in his jazz life.

In 1977, Bradley gathered a solid core of jazz lovers, including his old friend Bob Hayden, and started the Cape Cod Jazz Society, an organization that in about twenty-five years of existence, did much to promote jazz and support jazz musicians on Cape Cod.

Bradley said he envisioned creating a permanent home for the jazz society and even took out an option to buy a building in Yarmouth, but plans never materialized. Instead, the jazz society became a club that staged concerts and held monthly meetings of jazz fans.

All the time, Bradley maintained a veritable museum of jazz in his Harwich home. Thousands of records, books, photographs, instruments, newspaper clippings, films and assorted memorabilia filled nearly every room. Authors researching Armstrong flocked to Bradley's house to examine his vast holdings and ask questions from an eyewitness to jazz history.

Bradley's connections to the jazz world are so strong that he was able to get Dizzy Gillespie, perhaps the biggest jazz name of his generation, to come to Hyannis to play at a Sunday afternoon charity benefit event in the 1980s. When it came time to find musicians for a Cape Cod Jazz Society

concert, Bradley could always be counted on to come up with just the right talent for the event, often someone from the mainstream or traditional jazz schools that he loves.

In 2005, after long negotiations, the Louis Armstrong House Museum acquired the Jack Bradley collection. Today, Bradley's collection has been extensively catalogued and makes up much of what is housed in the museum. It has also been featured in a special exhibit at the museum. "The Jack Bradley–Louis Armstrong Collection cannot be replicated. It is the result of a very special relationship between its subject, Louis Armstrong, and its compiler, and of decades of dedicated work by that compiler," wrote the eminent jazz historian Dan Morgenstern.

Bradley cherishes his Armstrong memories and told a reporter in 1998 that when he first heard Armstrong play, at that early 1950s Hyannis concert, "the music went straight to my heart."

In 2016, Bradley recalled the time he walked into Armstrong's study in what is now the museum in Queens and saw Armstrong meticulously going through a stack of papers, carefully tearing up letters and other documents and throwing them into a wastebasket. "Louie, what are you doing?" Bradley recalled asking, horrified that important memorabilia was being thrown out. Armstrong said he didn't need the items and was tearing them up so that collectors such as Bradley would not be burdened with them. Bradley recalled that he convinced Armstrong to let him rescue some of the items before they were destroyed. With that kind of access to Armstrong's personal papers, it's no wonder Bradley's collection came to be among the greatest in the world.

As for his thousands of Armstrong photographs, Bradley is well aware that he was in the presence of a most photogenic man. "He was the greatest subject in the world. It was impossible to take a bad picture of him," Bradley said.

Mick Carlon, a Cape Cod–based author of several young adult books with jazz themes, recalled consulting Bradley as he wrote his book *Travels with Louis*, published in 2012. "There's a lot of inside stuff in that novel that came from Jack," Carlon said. So it was with great trepidation that Carlon brought Bradley a copy of the manuscript. His apprehension turned to joy, however, when Bradley called to tell him, "You've captured the man I knew."

Carlon's book, which tells the fictional tale of Armstrong befriending a twelve-year-old from his neighborhood and teaching him the trumpet and life lessons, has been adopted by many schools as part of their curriculum and has been favorably reviewed many times. Carlon, who, like many other writers, has spent a great deal of time with Bradley, said the authenticity in his book came from informally interviewing Bradley for fifteen years.

Carlon, who accompanied Bradley to the Louis Armstrong House Museum, said he was struck by the respect Bradley got from musicians when the two dropped by a couple of jazz clubs to hear some traditional jazz bands. "The musicians practically genuflected in front of Jack," Carlon said.

DICK GOLDEN

It's a warm summer evening on Cape Cod. After traveling much of the day and dealing with the traffic on the Sagamore or Bourne Bridge, you are finally able to relax in your cottage by the sea. This is what you wait for all year.

And the moment is about to get better. From the radio comes the sound of jazz—the soft sounds of Stan Getz, anything by Ellington or Louis Armstrong. Mix in some Cape favorites such as Bobby Hackett, Dave McKenna or Ruby Braff. And then bring in the singers, Rosemary Clooney, Frank Sinatra, Ella Fitzgerald and regular Cape visitor Tony Bennett. One after another, for four hours each evening, these wonderful sounds fill the Cape Cod night. For casual listeners—but especially for lovers of jazz and the Great American Songbook—this was not a fantasy. The program was called *Nightlights*, and its personable host was Dick Golden, who ruled the Cape Cod airwaves benevolently for nearly three decades.

Golden almost singlehandedly brought jazz to Cape Cod radio, starting in 1977, when he premiered his program, originally called *PM Cape Cod*, on WQRC-FM. Through good times and bad, Golden kept the jazz flame burning for twenty-eight years.

Golden grew up at a time when radio was a vital part of American life—a time when hosts were able to put their individual stamp on a program by selecting the music to be played and by presenting it in an individual way. "My ears were opened, at an early age, to well-crafted songs performed by artists who could communicate to listeners on more than just an audio level… who could make an emotional connection with the listener," Golden told interviewer Mick Carlon for an article published in *Jazz Times* magazine.

Golden started in radio in Portsmouth, New Hampshire, while still a teenager and showed a propensity for getting jazz on the airwaves by interviewing Count Basie—a legendary jazz pianist and bandleader—who showed genuine concern for the teenager and gave a thoughtful interview.

His career on Cape Cod was still to come. In 1970, Golden was hired by Falmouth's WCIB-FM to be the station's first program director. While

Dick Golden, who brought jazz to the Cape Cod airwaves for decades, in a familiar setting: his studio. *Author's collection.*

there, he was bringing jazz to the Cape, even though the station's format was non-jazz. He remembered doing a live interview from the Cape Cod Melody Tent in Hyannis with his old acquaintance Count Basie, who was performing there. Also on the Cape was Tony Bennett, who joined the interview, followed by Bobby Hackett, who was also performing nearby. It would have been a rare trifecta for a radio host in New York or Chicago. In out-of-the-way Cape Cod, it was miraculous.

Just two years after his arrival on the Cape, Golden made the move that would forever alter his career and the musical landscape of Cape Cod. He was hired by Don Moore, the visionary owner of WQRC-FM, based in Hyannis. Soon, Golden was given the responsibility of producing long-form programs, and he often used them to feature the Cape's array of jazz musicians, including Dave McKenna, Marie Marcus and Bobby Hackett, as well as visiting musicians, including Teddy Wilson and many others. Any time the fledgling Cape Cod Jazz Society was planning a fundraising event, it had a friend in Golden, who would promote it on his program.

Golden's 1974 tribute to Duke Ellington after Ellington's death won a Tom Phillips Award from the UPI Radio Network. Then came the kind of offer most radio hosts can only dream of. "In the summer of '77, Don

Moore called me into a studio and talked about a program where I would play only 'top shelf' music." He said Moore gestured as if reaching to the highest shelf in the studio.

Within a short time, *PM Cape Cod* was on the air with its mix of easy-on-the-ear jazz and American standards. Until that point, WQRC had been "the station you fell asleep to," according to Golden, playing only easy-listening instrumentals at night.

"The first reaction from some listeners was 'What the hell have you done to our radio station?'" Golden recalled. But Moore stayed the course, and soon the program developed a loyal audience of locals and the Cape's many visitors.

Eventually, the program was renamed *Nightlights*, and it became a part of the musical landscape on Cape Cod and as far away as WQRC's fifty-thousand-watt FM signal would carry. His listening audience stretched to much of southeastern Massachusetts and into Rhode Island as well as to the islands of Nantucket and Martha's Vineyard. "I think of people who are in their cars between Plymouth and the Sagamore Bridge. It's six miles to the bridge. It's a lot better if Frank Sinatra or Billie Holiday is singing 'Easy Living,'" Golden told an interviewer in 1997.

On several Christmas Eves, Golden hosted live broadcasts of Dave McKenna's performances from the Asa Bearse House in Hyannis, at that time a jazz club.

Golden would routinely get calls from listeners—some famous names among them—commenting on the music he played and suggesting songs for the program.

Golden's program thrived at a time when other Cape Cod radio stations were also venturing into jazz. WFCC-FM for a time had Jack Bradley hosting a show, along with Lou Dumont. WMVY-FM, originating on Martha's Vineyard, presented a Sunday morning jazz program for years. Provincetown-based community radio station WOMR has presented jazz for many years with a variety of program hosts.

Prior to Golden's arrival on Cape Cod, Dan Serpico hosted a popular program featuring jazz on Cape Cod's first radio station, WOCB. In 1961, *Down Beat* magazine reported that Serpico recorded an interview with Louis Armstrong during the great trumpeter's engagement at Storyville Cape Cod, and he would air it on his *Dan's Den* program.

But none of these jazz programs had the kind of staying power that *Nightlights* had.

In a moment that can only happen in a place like Cape Cod, one day a man dressed in fisherman's gear walked into the WQRC lobby and asked

to speak to Golden. It turned out the man was a commercial fisherman and heard him play a version of the Gershwin classic "Summertime" while navigating into Hyannis Harbor the night before. "I need to get that record," the fisherman said. Golden was happy to give the man the information he was looking for (the record was by pianist Gene Harris), and he left happy.

Golden says that episode and many others convinced him that Cape Cod is a special place for jazz lovers. "There is something in the air that attracts creative people," Golden says. "It goes to what it is about that 60-mile peninsula that has attracted people in so many endeavors." Golden points out that in addition to the many jazz musicians who called Cape Cod home, artists, writers and actors, including Edward Hopper, Kurt Vonnegut and Julie Harris, have also chosen the Cape.

Golden said a favorite moment for him was when, during his program, he would go outside the studio. "About 9:30 at night I'd go outside, breathe in the air." He said if perhaps it was foggy, he would go through the "3 by 5 cards in my mind" and maybe select Ella Fitzgerald and Stan Getz doing "Lost in the Fog." That song would then inspire another choice. "It's like creating a soundtrack, creating an indelible impression in people's minds. And, like a jazz performance, you're doing it in the moment."

Golden always found time to interact with his many listeners and with the jazz musicians performing on Cape Cod. As master of ceremonies at innumerable concerts and club appearances, he would introduce the performers, always educating his audience.

Golden also ventured into local television, hosting a program in the 1990s created by Ivy Sinclair called *Just Jazz* for Cape Cod's local access channel. Sinclair was able to book top talent, including Dave McKenna and Marie Marcus, to perform for free on the program. Tapes of that program remain as important historical and musical documents.

In 1997, WQRC, by then under new ownership, tried to reduce *Nightlights* to weekends only, a move that touched off the kind of outrage that's rarely seen. Hundreds of people wrote to the station to complain about the move, among them Tony Bennett, Carly Simon, George Shearing and Michael Feinstein. Station management relented, and once again, *Nightlights* was on seven nights a week.

Golden is philosophical about his role: "You can't be a personality and play this kind of music. After you say 'Here's Duke Ellington,' get the hell out of the way. This music is so glorious you just step out of the way." But even good things end, and just before Christmas 2005, Golden aired his final *Nightlights* program after taking a job handling external relations at George

Washington University in Washington, D.C. There, he continues to host a jazz program—which is heard over satellite radio by listeners around the world—and introduces a new generation to great American music.

KARYN HEWITT

She is not a musician. She doesn't own or operate a nightclub or concert hall. But Karyn Hewitt may be responsible for filling more seats at more jazz events than anyone else on Cape Cod. For Karyn Hewitt, jazz is more than a hobby and less than a vocation. But it's a way of life. "When I go to live music events, I'm just so happy. I feel better," Hewitt said.

Hewitt decided to dedicate herself to promoting music on Cape Cod after the death of her husband. "Volunteering is a pleasure. I decided I would just get out there and do something," is the way she described her decision.

Karyn Hewitt, who has done as much as anyone to promote jazz and develop a sense of a jazz community on Cape Cod. Here, she holds a copy of a famous Art Kane photograph at an event staged to emulate the Great Day in Harlem. *Photo by the author.*

Over the past decade, she has become a one-woman clearinghouse of jazz information. Her e-mails promoting jazz events are well known in the jazz community and anticipated by many musicians and fans alike.

Perhaps her crowning achievement as a jazz lover was the day in 2012 when Hewitt gathered together dozens of jazz musicians with ties to Cape Cod for a group photo that was a re-creation and homage to the famous Great Day in Harlem photograph taken by Art Kane in 1958.

Hewitt's reputation in the Cape Cod jazz community worked in her favor when she asked musicians to show up at the Cultural Center of Cape Cod in South Yarmouth on Sunday morning, April 1, 2012.

She hired photographers, and when Sunday morning arrived, she waited to see who would show up. And one by one, they streamed in, some carrying instruments, some with spouses in tow. In short order, the musicians were assembled, and the photos were taken.

"I suppose the original photo from Harlem stayed in my mind. I thought how nice it would be to honor the musicians and singers who have played jazz on Cape Cod." With musicians Bart Weisman and Alan Clinger helping get the word out, the Cultural Center's executive director Bob Nash offering the use of the building (a former bank that is as close as Cape Cod has to a brownstone) and the nearby Riverway restaurant providing lunch for everybody, the day was a success.

On April 1, 2012, dozens of jazz musicians with Cape Cod ties gathered for a group portrait to emulate the famous Great Day in Harlem photograph of 1958. *Photograph by Bob Tucker, from the Karyn Hewitt collection.*

"For me it was to honor and thank everyone for sharing years of their talent and marvelous music," Hewitt said. "A side benefit was to see and hear the joy of musicians meeting. For some of them it had been many years since they had seen one another."

While Kane's original photo featured such jazz stars of the 1950s as Count Basie, Gerry Mulligan, Thelonious Monk and many others, the Cape Cod photo featured such players as Bruce Abbott, Ted Casher, Bart Weisman, Ron Ormsby, Carol Wyeth, Paul Nossiter, Mike Crocco and others who have been part of the Cape Cod scene. Some musicians were forced to miss the photo shoot because prior commitments took them to gigs away from Cape Cod. Such is the life of a jazz musician.

Cape Cod jazz favorites of the past were not overlooked.

"We left a chair for Lou Colombo, who had died three weeks before," Hewitt said. His daughter, Lori Colombo, held a photograph of the great trumpet player. The empty chair was also a symbolic reminder of many jazz players who passed away after making their marks on Cape Cod.

The group portrait taken that day will live for generations as a reminder of Cape Cod's great jazz heritage.

CAPE COD JAZZ FESTIVAL

It happened only once, and to jazz fans on Cape Cod, it seems like a dream. The first, and only, Cape Cod Jazz Festival of 1980 brought together a wealth of talent, local and international, over Memorial Day weekend.

The lineup, divided between afternoon and evening performances, included the New Black Eagle Jazz Band, then and now among the top traditional jazz outfits in the world; a presentation of rare early jazz films from Jack Bradley's collection; Roomful of Blues, a small swing band; Dick Johnson's band; and the Buddy Rich band. And that was just the Saturday lineup.

On Sunday, a tribute to Bobby Hackett featured the Marie Marcus Quartet; more jazz films; Lou Colombo; Dick Wetmore; the Scott Hamilton Quartet; and the Bobby Hackett Memorial Jazz Band, a true all-star aggregation featuring Doc Cheatham on trumpet, Vic Dickenson on trombone, Chuck Folds playing piano, Phil Flanagan on bass and Bobby's son Ernie Hackett on drums.

On Sunday night, local favorite Marie Marcus returned with a Dixieland band, Cheatham and Dickenson returned with Bob Wilber and

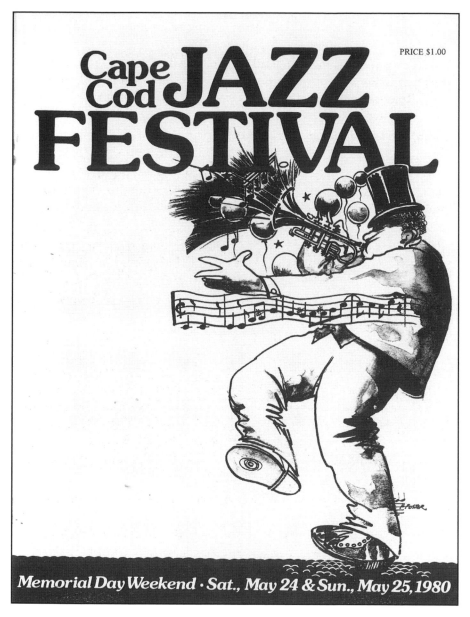

PRICE $1.00

The first jazz festival ever held on Cape Cod was sponsored by the Cape Cod Jazz Society in 1980. *Author's collection*.

Pug Horton and one of the all-time great jazzmen, Earl "Fatha" Hines, appeared with his quartet before Widespread Depression, a retro swing band, closed out the festival with guests Bob Wilber and Pug Horton.

The festival was a mammoth affair by big-city standards, and for rural Cape Cod, it was nothing short of a miracle.

The festival was the brainchild of Jack Bradley. "This is probably the largest congregation of great jazz talent to appear on the Cape at one time," Bradley wrote in the festival's program book. It concluded, "Hope to see you all next year."

The Cape Cod Jazz Festival attracted a good deal of media attention. Amy Lee's review in the *Christian Science Monitor* on June 4, 1980, carried the headline "Cape Cod Jazz Festival: Already a Trend-Setter?"

Lee raved about what she heard. "Scott Hamilton's group, the Widespread Depression Orchestra, Roomful of Blues, and even veteran pianist Earl (Fatha) Hines's quartet of young white jazzmen fired up a legion of jazz and blues classics and American pop standards with enthusiasm and skill. Melody staged a comeback. The familiar mellow old harmonies poured out, and the beat was solid and dancy." Lee quoted Bradley as welcoming the trend of fans appreciating classic jazz, while lamenting that the players in the revival were "mostly young white musicians so far."

Lee found fault with the festival's pacing, lamenting the fact that the Buddy Rich band didn't get onstage until 11:00 p.m. She also seemed less than enthusiastic about the Rich band's musical approach, saying it was "so overloaded with dexterity that it cows even admirers, antagonizes others or scares them off." But she found plenty to like in Rich's drumming. "He is the centerpiece of his band. Everything it does emanates from and is indivisible from that drum center. Buddy could sit on stage all by himself, without a horn in sight, and make music."

Lee was impressed by the tribute to Hackett, Cape Cod's adopted son:

> Cheatham, tall and straight as a redwood, his trumpet pointing characteristically skyward, offered lyric, Armstrong-like solos on "Rose Room" and Hoagy Carmichael's "New Orleans." Dickenson played a tender, affecting trombone solo on a tune he said "always intrigued" him, one that Bobby played—"A Room with a View." They were joined by trumpet/cornet men Dick Wetmore, Lou Colombo, Bob Branca, and Jim Blackmore, who spoke warmly of Bobby's meaning to them and played individual tributes.

Lee also wrote warmly of Marie Marcus, who, she said, "plays fistfuls of piano" and drew "rousing applause" from the audience.

In the *Boston Globe*, jazz critic Ernie Santosuosso wrote that "the unquestioned darlings were trumpeter Doc Cheatham, 75, and trombonist Vic Dickenson, 74. Even Dickenson's outrageously misdirected jam session, which saw enough musicians onstage to fill Filene's Basement, was converted into a triumph."

The Cape Cod Jazz Festival was not videotaped, and no audio recordings were made, so published reviews and recollections of those who were there are all we have to rely on. But it seems the foundation was put in place for future festivals. However, that was not to be.

Bradley said the festival—while no doubt an artistic success—was not a financial success, making it difficult to put together another event of that size. The logistics of bringing in top jazz players from around the country and paying them what they are worth is daunting for professional promoters. A volunteer group like the Cape Cod Jazz Society couldn't be expected to follow up.

Decades later, the Cape Cod Jazz Festival name resurfaced, but the festival has no connection to the 1980 event. The current Cape Cod Jazz Festival is not a traditional festival, as was the first event to bear its name, but is staged two nights a week in July and August at the Wequassett Resort and Golf Club in Harwich by Robert Talalla Productions. The festival presents a wide range of contemporary jazz talent and is a distant echo of the 1980 event, which relied heavily on traditional jazz stars.

CAPE COD JAZZ SOCIETY

For about twenty-five years, the Cape Cod Jazz Society (CCJS) presented concerts, educated people about jazz, brought jazz to the schools and served as a social club.

Founded in 1977 by Jack Bradley and a group of jazz lovers, the society quickly attracted 150 dues-paying members according to a *Cape Cod Times* article. Among the early members was Bob Hayden of Cotuit, whom the *Times* article referred to as "a contractor, collector of everything from records to buildings, and expert at large."

Musicians Jim Cullum and the Cape's First Lady of Jazz, Marie Marcus, were also among the founders. They were joined by Jim Blackburn, Frank Foster, Alice Carey, Del Antoin, Dick Kelly and Ben Thacher as the jazz society's first board of directors.

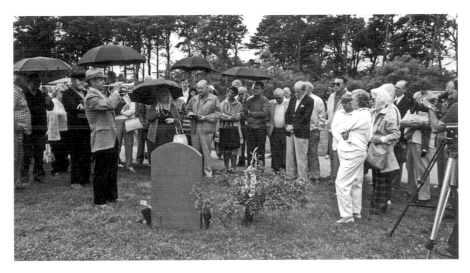

Gordon Brooks plays cornet, re-creating a Bobby Hackett solo at the unveiling of Hackett's gravestone in Chatham. *Jack Bradley photo.*

The jazz society's first meeting, held in Harwich and featuring a jazz concert, attracted such a large crowd that the police were called to control the traffic. "It was just fantastic," Bradley was quoted as saying.

As one of its first acts, the jazz society raised the funds to purchase a gravestone for Bobby Hackett's grave in Chatham's Seaside Cemetery.

Throughout its quarter century of existence, the Cape Cod Jazz Society was responsible for staging concerts featuring top local, national and international talent. The jazz society staged events as large as the Cape Cod Jazz Festival of Memorial Day weekend 1980 and as intimate as annual Christmas parties featuring local musicians.

A 1978 concert held at the Nathaniel Wixon School in South Dennis featured the New Black Eagle Jazz Band. For five dollars (four for CCJS members), jazz lovers got to hear one of the nation's top traditional jazz units.

In March 1984, the jazz society put together a concert featuring four top piano players playing solo sets. The opening acts were all Cape Cod favorites: Mike Markaverich, Jack Bumer and Marie Marcus. Then came the headliner, Dave McKenna.

One 1986 concert featured tenor saxophonists Buddy Tate and Scott Hamilton representing two generations of jazz.

In 1987, the jazz society celebrated its tenth anniversary with a concert that featured Ruby Braff, Scott Hamilton, Benny Waters, Gray Sargent and the White Heat Swing Orchestra.

In November 1977, the CCJS presented a dance concert featuring eminent saxophonist and clarinetist Dick Johnson at the Ocean Park Inn in Eastham on the Lower Cape. The event also featured a jitterbug contest, which must have been a crowd-pleaser for people raised in the swing era.

One 1980s concert, billed as the Harwich Jazz Festival, saw the jazz society getting together with several other community organizations to stage a two-day event. Jazz stars on the program included Marie Marcus and her Dixieland Band, the Bob Hayes Quartet with Dick Wetmore and Lee Childs and the Bourbon Street Paraders. And that was just one day's lineup. Other bands playing that weekend included the Paul Jones Jazzboat Band and others.

In its heyday, the CCJS published its own magazine, *Jazz Notes*, initially produced singled-handedly by Jack Bradley. This monthly publication nearly became a full-time job, as Bradley typed the copy, acquired the photos and took the whole project to a local printer. Copies of *Jazz Notes* are still found in many Cape Cod homes of jazz fans. Articles about local and nationally known musicians were published alongside listings of upcoming jazz events and photos, often from the famous Jack Bradley collection.

The Cape Cod Jazz Society's membership included many locals but also had members as far away as Australia. Plenty of Boston and New York people, many with Cape Cod summer homes, were also members.

But, like so many organizations, the CCJS began to lose steam as its membership aged. Composed primarily of retirees, the jazz society could not sustain a large membership. Also, its core audience of jazz lovers, who came of age in the swing era of the 1930s and '40s, began to fade away.

Through the 1980s and 1990s, the jazz society consistently presented top jazz talent in concert settings and at parties held at various sites around Cape Cod. It was not unusual to have a turnout of more than one hundred people for a Sunday afternoon Christmas party in Dennis or a Labor Day event in Harwich or Osterville. The jazz society's members expected good music and always got it at these events.

Glenn Maggio, who served for several years as president of the jazz society and also produced many of its concerts, called this "the golden age of jazz on Cape Cod."

In June 1998, CCJS staged an event that would pay tribute to one of Cape Cod's jazz giants and return the jazz society to its roots. "We Remember Bobby," a concert honoring Bobby Hackett, was held at Cape Cod Community College and featured a band of Cape Cod favorites: Warren Vache, cornet; George Masso, trombone; Dave McKenna, piano; Marshall Wood, bass; and

Gary Johnson, drums. The concert was, in a sense, a further outpouring of affection for the great trumpet man who chose Cape Cod as his home.

A Duke Ellington centennial tribute concert sponsored by the jazz society included the reading of a letter from then-president Bill Clinton, who praised Ellington as a great American musician and the jazz society for honoring him.

Concerts staged by the jazz society featured traditional and swing musicians, including Ed Polcer and Vince Giordano (known as the leader of the Nighthawks band), as well as singers like Barbara Morrison from the West Coast. But the tide had turned, and sustaining major concerts was no longer possible for an organization whose membership was aging and not being replaced by younger jazz fans.

Over its lifetime, the CCJS was well served by jazz fans who shared their time and energy to promote the music. Among the many who gave much to keep the organization running were Glenn Maggio, Jack Maslen, Lorraine Carroll, Hut Howell, Harris Contos, Rigmor Plenser, Mert Goodspeed and others too numerous to mention.

Shortly after the turn of the century, jazz society events got smaller and less frequent, although they were consistently strong artistically.

As its last act, the CCJS continued to support a youth band led by professional musician Rod McCaulley (who also served a term as the president of the jazz society). Dozens of high school students passed through the band over the decade or so that it existed, gaining knowledge of jazz and learning to perform with others in a group setting.

When the last of the CCJS treasury ran out, the youth band folded, and with it died the Cape Cod Jazz Society.

ON THE RECORD

Musicians who are associated with Cape Cod are well represented on record, from nationally distributed labels to tiny, local labels.

In the case of some Cape musicians from years past, records can be hard to find, but dedicated collectors often enjoy the pursuit.

For jazz fans, putting together a collection of recordings by Cape Cod jazz musicians can be challenging but also musically rewarding.

Here is a list of some records by musicians with Cape Cod connections. It is by no means complete, and record collectors are encouraged to

conduct their own searches for some of the musical treats recorded by jazz musicians with Cape Cod ties.

Marie Marcus

There are few recordings by Marie Marcus as a group leader, but online sources will quickly turn up plenty of records she made as the pianist in the Dixieland group Preacher Rollo and the Five Saints. *Dixieland Favorites* and *At the Jazz Band Ball* both are sought after by collectors.

Bobby Hackett

Trumpet plyer Bobby Hackett recorded hundreds of albums, with everything from lush orchestral backings to small combos.

The Bobby Hackett Quartet on Capitol Records is a special treat because it also features Cape Codder Dave McKenna on piano.

Hackett recorded a string of albums in conjunction with Jackie Gleason on which the jazz was limited but the playing was beautiful. Many are available on CD.

Bobby Hackett with Vic Dickenson Live at the Roosevelt Grill remains a popular Hackett album and is readily available on CD reissues and on LP in secondhand record shops.

Dave McKenna

Pianist Dave McKenna was a perfectionist and sometimes reluctant to record, but ultimately, he was persuaded to go into the studio. Jazz fans are better off for it.

McKenna recorded often as a solo pianist, and that may be the best setting for him because it allows his booming left hand to be featured. Among the favorites in this genre is *Left-Handed Complement* from 1980 on Concord Records.

Live at Maybeck Recital Hall is proof that McKenna reached the highest level as a pianist. Only the top jazz players were invited to be part of this prestigious series by Concord Records.

Blues Up is a reissue on the Fresh Sound label of two of McKenna's early LPs: *Solo Piano* from 1955 and *Lullabies in Jazz* from 1963.

No Bass Hit features saxophonist Scott Hamilton and drummer Jake Hanna. Who needs a bass player when McKenna is on the scene?

Ted Casher

Not widely recorded, but worth seeking out, is saxophonist/clarinetist Ted Casher. His quintet LP *Movin' Back* from the 1980s features Mike Garvan, another Cape Cod favorite, on piano and all original compositions by Casher and other members of the band.

Bruce Abbott

Saxophonist Bruce Abbott brings good taste and fine playing to everything he records. His records on the North Star label include *Romancing the Sax*, which finds him backed by strings. *Mistletoe Sax* offers jazz versions of Christmas classics. He has also recorded with guitarist Fred Fried.

Ruby Braff

With hundreds of recordings to his credit, Ruby Braff's career is well documented. The records that first brought Braff to the attention of many jazz fans were made with trombonist Vic Dickenson in 1953 and are available as *The Vic Dickenson Septet Vols. 1 and 2*.

From his early years, *Braff!!* on the Epic label is also noteworthy.

From the Cape Cod years, listeners have many choices. *The Cape Codfather*, released on Arbors Records in 2000, is prime Braff, always swinging and tasteful on tunes both familiar and obscure. With bandmates Kenny Davern and Tommy Newsome, this is one of Braff's finer records. *Ruby Braff and His New England Songhounds* also will not disappoint. Recorded for the Concord Jazz label and released in 1991, it features Dave McKenna on piano and Scott Hamilton on tenor sax.

Braff recorded prolifically in his later years, which coincided with his years on Cape Cod, and all the records he made then are worth finding.

Lou Colombo

Almost criminally under-recorded, trumpeter Lou Colombo's music is available on CD and LP to those who care to look for it.

One fine Colombo record, never reissued on CD, is the one he recorded with Dick Johnson, Dave McKenna and others at Johnny Yee's in West Yarmouth on Cape Cod. Copies of the LP, when they can be found, usually sell for relatively high prices online and in record shops.

Perhaps the recording of Colombo's that brings the Cape Cod jazz experience full circle is his *I Remember Bobby* CD released by Concord Jazz in 2004. The entire album is a tribute to Bobby Hackett, a trumpeter who adopted Cape Cod as his home, as did Colombo, and the title track is written by Dick Johnson, the great saxophonist who was a favorite of Cape audiences. Add another Cape favorite, Dave McKenna, on piano, and this may be the quintessential Cape Cod jazz disc.

Colombo also turns up on dozens of recordings as a sideman. He is featured on an album Dick Johnson made in 2006, *Star Dust and Beyond*, a tribute to Artie Shaw. Colombo is also a key player on several CDs by trombonist George Masso. Try *C'Est Magnifique* on the Nagel Heyer label and *That Old Gang of Mine* on the Arbors label.

Greg Abate

Greg Abate was a young saxophonist just starting on his musical journey when he led Channel One on Cape Cod in the early 1980s, and that band made one LP that holds up today as an example of rock-influenced jazz. It's not easy to find, but collectors still seek it out.

More recently, Abate has made a string of first-class records that show off his bebop and post-bop chops. Try *Kindred Spirits*, recorded with another great saxophonist, Phil Woods. Also recommended is *Straight Ahead*, a collection recorded in 1992 featuring trumpet player Claudio Roditi. *Motif* finds Abate in good musical company on a collection mainly made up of Abate originals.

Mike Markaverich

Not widely recorded, but worth looking for, Mike Markaverich recorded an LP while he was working on the Cape that stands the test of time. *Two Sides*

from 1988 features only Markaverich on piano and Bill Britto on bass, and it is an album of subtle, swinging jazz, notable for the inclusion of some modern jazz classics, including John Coltrane's "Naima," Freddie Hubbard's "Up Jumps Spring" and Charlie Parker's "My Little Suede Shoes," among others.

Dick Wetmore

Dick Wetmore's best records were out of print for decades but have found a new life on the reissue market in recent years.

Among his best is an album simply called *Dick Wetmore*. It was originally issued by Bethlehem Records in 1955. On this record, Wetmore, on violin, is joined by Boston piano legend Ray Santisi, Bill Nordstrom on bass and Jimmy Zitano on drums playing a program of songs by Bob Zieff. The album essentially defines how modern jazz was to be played on the violin.

Another disc worth hearing is *Stringtime* by Gerry Mulligan and featuring Wetmore as a member of the Vinnie Burke String Jazz Quartet. Recorded in 1957, the music is still vibrant and innovative. The music was reissued as part of Mosaic's Gerry Mulligan box set, and tracks have been reissued in various forms on Mulligan albums.

Bob Hayes

A fixture on the Cape Cod music scene, Bob Hayes has recorded in a variety of settings. In recent years, he has been joined on record by his grandson, drummer Kareem Sanjaghi, as well as by other top performers from Cape Cod and elsewhere.

Hayes's 2007 CD *Society by the Sea* features Laird Boles on bass as well as Sanjaghi on drums. His 2013 CD *Grand Slam* is highlighted by Kenny Wenzel on flute and flugelhorn and Marshall Wood on bass.

Concord All-Stars

Jazz on Cape Cod got some well-deserved national attention in 1992 when the Concord Jazz record label came to Hyannis to record a group of musicians playing the kind of straight-ahead, swing-oriented jazz that is often heard along the beaches and sand dunes of Cape Cod.

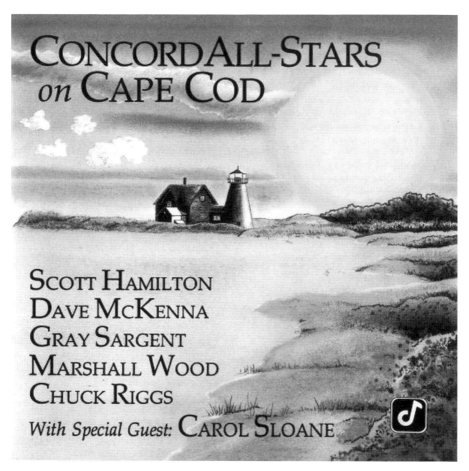

CONCORD ALL-STARS
on CAPE COD

SCOTT HAMILTON
DAVE MCKENNA
GRAY SARGENT
MARSHALL WOOD
CHUCK RIGGS

With Special Guest: CAROL SLOANE

Cape Cod's jazz heritage went national and international when Concord Records came to the Cape for a recording session. *Concord Records.*

Featuring Dave McKenna, piano; Scott Hamilton, tenor sax; Marshall Wood, bass; Gray Sargent, guitar; and Chuck Riggs, drums, with singer Carol Sloane, and performing before a live audience, this band cooks from first note to last.

Bibliography

Balliett, Whitney. *American Musicians: 56 Portraits in Jazz*. New York: Oxford University Press, 1986.

"A Cocktail Lounge Saloon Song Player: An Interview with Dave McKenna," *Boundary* 22, no 2 (Summer 1995).

"A Conversation with Dick Wetmore. The Life and Music of a Moderately Successful Jazz Violinist." As told to Jamey Wetmore, November 2002– April 2003. Unpublished transcript of interview.

Simon, George T. *The Big Bands*. New York: MacMillan Company, 1967.

Vacca, Richard, *The Boston Jazz Chronicles*. Belmont, MA: Troy Street Publishing, 2012.

Index

A

Abate, Greg 22, 57, 120
Abbott, Bruce 12, 19, 22, 27, 37, 46,
 68, 111, 119
Atlantic House 12, 83, 84, 85, 87

B

Benford, Tommy 32
Bournehurst 12, 75, 76, 77, 78, 79,
 80, 94
Bradley, Jack 36, 40, 91, 94, 98, 99,
 101, 104, 107, 111, 113, 114,
 116
Braff, Ruby 7, 12, 38, 39, 40, 41, 51,
 52, 60, 91, 105, 115, 119
Byrne, Donna 39, 51, 52, 53

C

Cape Cod Jazz Festival 106, 111, 113,
 114, 115
Cape Cod Jazz Society 106
Carlon, Mick 104, 105

Casher, Ted 54, 66, 111, 119
Childs, Lee 64, 65, 66, 116
Clinger, Alan 60, 110
Colombo, Lou 7, 12, 19, 20, 21, 22,
 24, 49, 53, 54, 57, 60, 63, 64,
 66, 68, 70, 71, 81, 93, 95, 98,
 100, 111, 113, 120
Columns, The 12, 26, 29, 36, 54, 80,
 81, 82, 83

D

Dunfey's 28, 29, 66

E

Excalibur 32, 34, 99

F

Foster, Frank 93, 94, 114
Fried, Fred 12, 38, 60, 62, 68, 119

G

Garvan, Mike 82, 119
Golden, Dick 8, 19, 20, 105, 106, 107

H

Hackett, Bobby 6, 12, 24, 27, 29,
 40, 44, 49, 50, 66, 81, 94, 100,
 103, 105, 106, 111, 115, 116,
 118, 120
Hallett, Mal 78
Hayes, Bob 55, 116, 121
Hewitt, Karyn 109
Holiday, Billie 83, 84, 85, 107
Horton, Pug 41, 112

J

Jazz Society 5, 18, 19, 22, 30, 44, 71,
 94, 103, 114, 115, 116, 117
Johnson, Dick 7, 21, 22, 53, 54, 57,
 60, 63, 68, 70, 81, 95, 100, 111,
 116, 120

L

Lou Colombo 70, 93, 111

M

Maddows, Warren 26, 54, 80, 83
Marcus, Billy 19, 49, 50, 51
Marcus, Marie 6, 12, 15, 18, 19, 48,
 49, 55, 64, 66, 70, 106, 108,
 111, 113, 114, 115, 116, 118
Markaverich, Mike 96, 115, 120
Marsland, Larry 96
McCaulley, Rod 38, 41, 70, 71, 117
McKenna, Dave 6, 7, 8, 12, 21, 24, 26,
 27, 28, 43, 44, 49, 53, 57, 66,
 80, 95, 100, 105, 106, 107, 108,
 115, 117, 118, 119, 120, 122
Mulligan, Gerry 34, 83, 85, 90, 102,
 111, 121
Muranyi, Joe 37, 46, 66

N

Newcomb, Tyler 49, 71
Nossiter, Paul 18, 19, 63, 64, 87, 88,
 90, 92, 93, 111

O

Ormsby, Ron 18, 82, 111

P

Panama Club 12, 17, 96, 98
Provincetown Jazz Festival 12, 46

S

Salerno, John 47, 48, 49
Sanjaghi, Kareem 57, 121
Shea, Frank 12, 43, 65, 66, 68
Storyville 12, 18, 63, 64, 87, 88, 90,
 91, 92, 93, 107

T

Tivoli 93, 94
Tracy, Tom 35
Travis, Chandler 34, 37, 72, 73

W

Wein, George 18, 63, 87, 88, 90, 91,
 92, 93
Weisman, Bart 44, 68, 93, 110, 111
Wetmore, Dick 30, 34, 68, 73, 111,
 113, 116, 121
Wilber, Bob 30, 41, 44, 66, 111, 112
Wood, Marshall 7, 8, 51, 117, 121, 122

About the Author

John Basile is known on Cape Cod as the longtime editor of the *Register* newspaper. Before turning to the newspaper field, he was for more than a decade a radio newscaster, first on WOCB and later on WQRC on Cape Cod, where he worked alongside Dick Golden, host of the popular *Nightlights* program.

While developing his career in journalism, he never lost his love of music, with a particular interest in jazz. As a "washashore" on Cape Cod like so many others, he was amazed to find a vibrant jazz scene on the sandy peninsula, and he made many friends among the Cape's musicians, highlighting them in feature stories whenever possible.

John and his wife, Kathryn, raised their two sons on Cape Cod.

First as a member of the Cape Cod Jazz Society and later as its president (succeeding the legendary Marie Marcus), he helped to present many jazz parties and concerts. Later, as a member of the board of directors of the Cultural Center of Cape Cod, he helped to organize jazz-related events, including concerts and art exhibitions.

He is an avid record collector and student of music history, particularly jazz and rock, and has devised and taught courses on jazz history, in

addition to serving on the board of trustees (and as president) of the South Yarmouth Library Association and on the board of directors of the Cultural Center of Cape Cod.

This is his second book. His first, *Legendary Locals of Yarmouth*, was published in 2014 by Arcadia Publishing.